LONDON

PORTRAIT OF A CITY

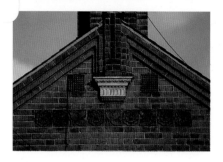

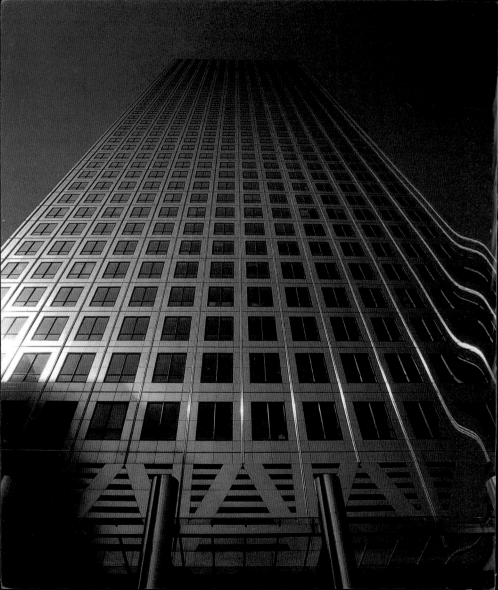

LONDON
PORTRAIT OF A CITY

Matthew Weinreb
Text by Ben Weinreb

For **Joan Weinreb**
1927–92

Phaidon Press Limited
Regent's Wharf,
All Saints Street
London N1 9PA

First published 1993
© 1993 Phaidon Press Limited

Photographs © 1993
Matthew Weinreb

This edition first published 1999
© 1999 Phaidon Press Limited

ISBN 0 7148 3859 4

A CIP catalogue record for this
book is available from the British
Library.

Printed in Hong Kong

Acknowledgements
The author and publishers
would like to thank all those
who have helped in the
production of this book, most
notably Susie Barson, Roger
Bourdler, Steven Brindle,
Julia Elton, Elain Harwood
and Andrew Saint for their
contributions to the essays.
The author would like to thank
Julia Elton in particular for her
invaluable guidance and help.

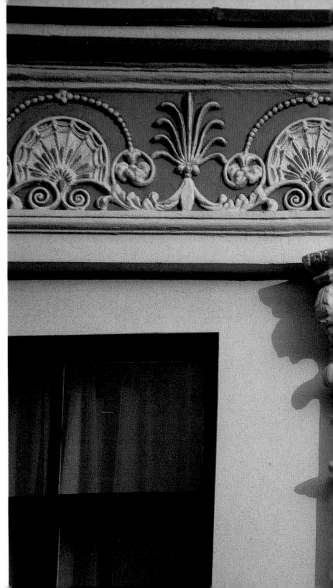

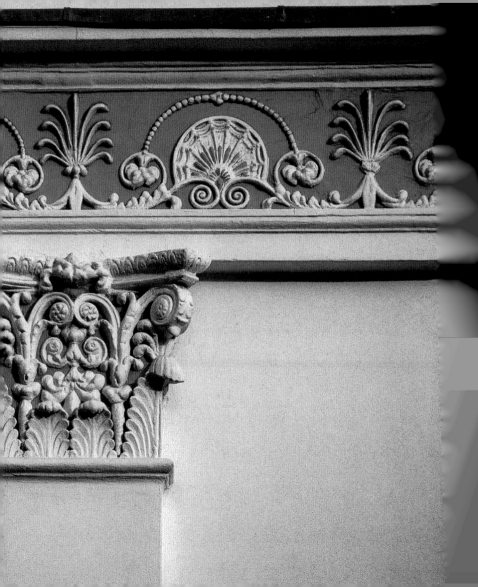

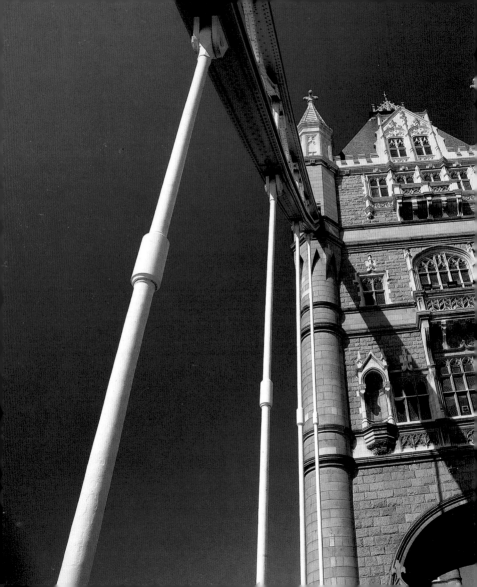

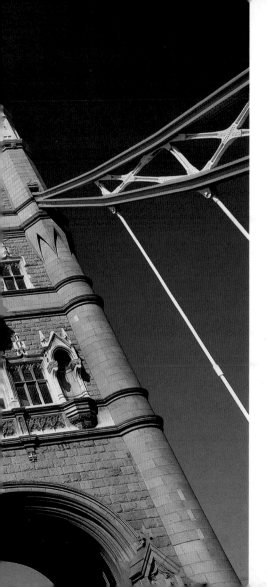

Previous pages
1 A brick gable end with decorative terracotta tiles in Teddington.
2 The pyramid-topped main tower of Canary Wharf on the Isle of Dogs, Docklands. Designed by Cesar Pelli it stands 787 feet high and is the tallest tower in Britain.

3 A characteristic Adam frieze and capital in Portland Place, Marylebone, completed in 1780.
Left Tower Bridge, the City. Opened in 1894, this bascule bridge with two lifting leaves was designed by the engineer Wolfe Barry and City architect Horace Jones.

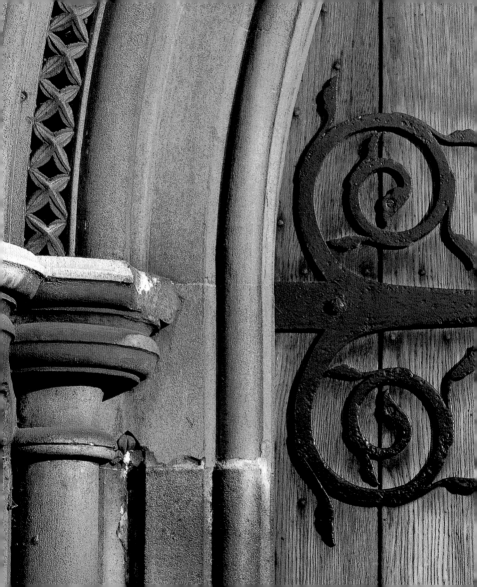

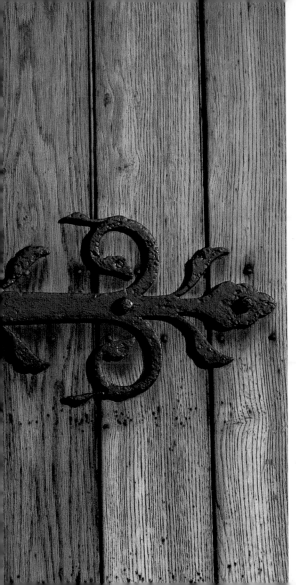

Foreword

This is not a book on the theory of architecture, nor is it a book on style. It is my attempt to capture the spirit of London's buildings; the buildings that make London what it is. Flattened perspectives revealing the patterns, both structural and decorative, integral to the buildings, are combined with rich architectural details, so often missed in the hustle and bustle of daily life.

Lighting is of utmost importance to architectural photography. It was therefore essential to plan shots meticulously. Knowing the orientation of a building, its relation to its neighbours and something of its history helped enormously, and for this I am grateful to Pevsner's London volumes, Jones and Woodward's *Guide to the Architecture of London*, and to my father.

I have lived in London all my life and have been an architectural photographer here for the last decade, yet I was largely unaware of the wealth of detail to be found. Many of the photographs were taken while wandering through the streets, alert to an overlooked corbel or decorative frieze, but always ready to return for a better light. Taking pictures for this book has opened my eyes. I hope that it does the same for others.

Matthew Weinreb, 1993.

Left The main door of St Anne's Church in Highgate.

Following pages 16/17 Monument, in the City, was designed by Sir Christopher Wren to mark the place where the Great Fire of London broke out in 1666. The Roman Doric column 202 feet high is built of Portland stone and is the tallest isolated stone column in the world. This spiral staircase of 311 steps leads to the balcony beneath the flaming urn.

9

Introduction

London has neither the grandeur of Rome nor the beauty of Paris. It boasts few of the pompous trappings of outdated power found in Vienna, and does not enjoy the advantages of a romantic setting like Venice. It is built within a saucer of clay and for much of its life has been wrapped in a blanket of fog. Yet such is the cut and character of the people this great city serves and which they themselves have built, rebuilt, and even now change faster than ever before, that some sixty years ago it was called 'the unique city'. It is so still.

The Danish architect and historian, Steen Rasmussen, who so named it, was writing before tower blocks blunted the skyline and highways sliced through historic neighbourhoods. Beneath the concrete towers London still retains its Inns of Court, its squares, its parks and palaces, its markets and even its tenements, and in every area they fight to save the vestiges of its past: a redundant church, a cast-iron pissoir or an old shop-front. It is not, however, these isolated landmarks that make the place unique but its shape, which reflects its history and the story of its people.

The cities on mainland Europe were built with fortified walls as protection against their rival neighbours; many of them had once been city-states. But London, since Norman times, has needed no walls, so whilst other cities were what Rasmussen calls 'concentrated', London was an open or 'scattered' city. Its long-established laws of privately-owned land prevented the imposition of a formal city plan, perhaps to its detriment, and preserved its open parks and spaces, for London has more than any other city.

London is two cities: the City of Westminster which was the place of Royal residence as well as the seats of Parliament and legislation; and the City of London itself with its riverside quays, banks and commercial exchanges. The two were quite separate with their own city regulations and even today, when the Sovereign wishes to enter the City of London, she asks permission to do so from its chief citizen, the Lord Mayor. But the Thames, the broad highway for ceremonial barges and thousands of watermen, linked them more successfully than any road could. London spread, slowly at first, along the river banks and then north and south, absorbing the small towns in its path, each with its parish church, its town hall, its small industries and its own distinctive character, until it achieved the doubtful accolade of being for some time the largest city in the world.

Rasmussen, writing in 1934, says, 'one of the mainstays of the English people was their utter ignorance of what was being said and done in other European countries'. That may have been his impression of much of the population, but it

was not true of English architects who, since the time of Inigo Jones, considered travel to be a necessary part of their education. A quick look through the pages of this book will show that what they drew in their students' sketchbooks they built as practising architects, whether it was to be the great portico of the British Museum or the blind-brick arcading on Kentish Town swimming baths.

Britain not only sent her young architects abroad but her writers, painters and scholars too. One need only think of John Milton, Richard Wilson and Edward Gibbon to appreciate the strong European influence brought to bear on her life, her art and her thought by native-born Englishmen. But even stronger has been the impact over the centuries of successive waves of immigrants, both fugitives and master craftsmen, who have enriched her with their skills and trades, and none more so than foreign artists.

The very first views of London were made by the Dutch, Flemings and Germans. Van Dyck, in the ten years before his death in 1641, transformed English portrait painting. Canaletto, who arrived in England from Venice a hundred years later, brought with him a new vision of the English scene which had a lasting influence on English landscape and townscape painting, as did the paintings of Whistler, Monet and Kokoschka on later generations.

Nearer to the subject of this book is the art of the printmaker, for both printmaker and photographer ultimately envisage their pictures within the confines of a printed page. All the early arts of the book – the woodcut, the copperplate engraving, the etching and later lithography – were brought to England by Dutch and German immigrants. Even William Caxton, the first English printer, learned his trade in Cologne and Bruges before setting up his workshop in 1476.

The earliest view of England to be engraved was by Francis Hogenberg, who was invited to London in 1568 by Sir Thomas Gresham to make a plate of his newly built exchange, later the Royal Exchange. Other German and Dutch topographical engravers followed, but the most notable was a Moravian, Wenceslaus Hollar, born in Prague in 1607 and brought to England by the Earl of Arundel in 1636. Hollar's views of London are the surest guide to what the city must have looked like over the forty years that he knew it. He shows us its buildings and people, its Parliament and even its executions, but above all London itself is revealed in his magnificent panorama of the Thames drawn from the tower of St Mary Overies (now Southwark Cathedral) illustrating all the buildings clustered round its banks from Whitehall to beyond the Tower. At the end of his life he produced *A New Mapp of the Cityes of London and Westminster with the Borough of Southwark & all the Suburbs*. It was advertised at the time as showing 'the severall Streets, Lanes,

Alleys, and most of the Throwgh-faires'. A reclining woman holds a placard on which is engraved, 'The Scale's but small, Expect not truth in all', a charming but unnecessary disclaimer.

The great age of London topographical printmaking was ushered in by a Dutch bookseller, David Mortier, who set up shop in the Strand in 1698 employing a Dutch artist and a Dutch engraver; Johannes Kip engraved a six-foot-wide perspective view *de la Ville de Londre Westminster et Parc St Jacques* as well as other views, and his collaborator, Leonard Knyff, painted the great London houses. Whilst they were active, a flourishing English trade developed which was fed by immigrant engravers who passed on their skills. Thus by mid-century print-making was a well-founded industry.

Between 1700 and 1800 some fifty books were published, from elephant folios to small pocket guides, containing between them over a thousand engraved views of London and its buildings, as well as many separately produced plates in aqua-tint and mezzotint. This was the age of 'The Grand Tour' when not only artists and scholars were travelling abroad but also wealthy young Englishmen, bringing back art treasures and fine view books from Rome, Florence, Venice and Paris. It created an informed and discriminating clientele who not only built themselves Palladian villas with galleries to display their newly acquired pictures and antiquities, but demanded of their publisher-booksellers books about Britain, particularly London, comparable to those produced abroad. Although none compare with the magnificence of Piranesi's *Vedute di Roma* and Zocchi's Florence or the magic of Carlevaris's and Canaletto's Venice, English topographical artists and engravers began to portray London in a similar way.

Some of the best engraved views of London at this time were made to illustrate an edition of John Stow's *Survey of the Cities of London and Westminster*, first published over 150 years earlier and now greatly extended and, as the title-page says, 'brought down to the present time by careful hands'. Publication began in 1754 in weekly parts, each part consisting of six folio pages of letterpress and one copperplate 'finely engraved all stitched in a strong wrapper at 6d per part'. The work took three years to complete and was then bound up in two large folio volumes, containing 132 engraved plates. As each plate took many weeks to engrave and as every impression had to be individually inked and pulled by hand, an immense amount of labour was involved.

The end of this period saw the publication of one of the greatest of all London picture books, the *Microcosm of London*. Its publisher, Rudolph Ackermann, producer of many fine colour-plate books and the proprietor of the grandest bookshop in

London, was the son of a German coach builder. For the *Microcosm* he engaged Thomas Rowlandson to draw the figures and Augustus Charles Pugin the architectural backgrounds. Rowlandson, a rumbustious caricaturist, was the best portrayer of 18th-century English life while Pugin, a refugee from revolutionary France, first employed by the Prince Regent's architect, John Nash, was soon becoming known as the best architectural draughtsman of his day. The book appeared in parts between 1808 and 1810, containing 104 splendid aquatint plates printed in colour ranging from *Mounting Guard at St James's* to *The Pass-Room for Female Paupers at Bridewell*.

Such was the demand for topographical engravings that the incised copper plates from which they were printed quickly wore down and had to be continuously re-engraved. In 1819, in an attempt to make forgery-proof banknotes, a method was invented of engraving on steel, a much harder metal, and this was also used for book illustration. The result was that picture books became inexpensive and popular. The most successful was *Metropolitan Improvements, London in the 19th Century*, published between 1827 and 1830 in forty-one monthly parts and containing 159 engraved views.

Concurrent with steel engraving was Alois Senefelder's new invention of lithography, brought to England in 1801. This was a method of drawing on stone with a grease-based ink and was to change the whole nature of print-making, for while the etcher-artist conceived his work in terms of etched lines and controlled the whole process from its original conception to the final print, the majority of artists and draughtsmen were dependent on the engraver to interpret and transfer their work on to a metal plate for printing. Lithography enabled the artist to draw directly on to the prepared stone and himself take impressions.

At first lithography was largely ignored in England by professional artists and was used mainly by amateurs, but it gradually gained acceptance. (Ruskin said, 'Let no lithographic work come into your house if you can help it'.) In 1842, *Original views of London as it is, drawn from Nature explicitly for this work and lithographed by Thomas Shotter Boys* appeared in which the lithographs were printed from two stones giving them a deeper range of tone so that when they were hand coloured they looked like watercolours. The technique was soon improved and before long many stones, each inked in a different colour, were being used and the coloured or chromolithograph developed. This was the method of colour printing in general use until it was superseded by photo-lithography.

At the end of this period comes the most inspiring of all the illustrated books on London, Gustave Doré's *London. A Pilgrimage* of 1872. Doré is valued not just for

the truth of his delineation's but for his vitality and the richness of his imagination. To him London was a city of people and, like Dickens, he recorded the whole panorama of London life. Born in Strasbourg, he lived most of his life in Paris but visited London frequently, even owning a gallery at 35 New Bond Street, now the site of Sotheby's famous auction rooms. His London drawings were first engraved on wood and then transferred by a new electro-photographic process on to a printing plate which allowed many more copies to be taken than had the woodblocks themselves been used.

Photography was invented almost simultaneously by Niepce and Daguerre in France and by Fox Talbot in England, but it was Fox Talbot's elaborate method of treating paper with silver nitrate, potassium iodide and potassium bromide which resulted in the Calotype process. The first book ever illustrated with photographs was Fox Talbot's *The Pencil of Nature*, published between 1844 and 1846, which contained twenty-four of his calotypes. This book is not only a landmark in the history of visual presentation and of books, but also in the history of the world for there are few inventions which have had a greater impact on our civilization. The technique was quickly improved upon, both by Fox Talbot himself and by others who adopted it. In 1847 a photographic club, the Calotype Club, was formed and amongst its dozen members were the earliest photographers of London.

Calotypes were used in a major publication to illustrate *The Reports of the Juries* of the Great Exhibition of 1851. One hundred and fifty-four photographs of the exhibited objects and of the building were required, and 130 special sets were printed for the Jurors and for presentation to the Queen, Prince Albert, cabinet ministers and heads of foreign governments. This necessitated over 20,000 separate calotypes. The photographs were taken by M Ferrier of Paris and printed by Hennman in Regent Street on silver chloride paper supplied by Fox Talbot. Photography had quickly become an international and prestigious business.

An indication of the rapidity with which the new invention was adapted to commercial use is that by 1858 the London Stereoscopic Company was advertising a stock of 100,000 different photographs of famous buildings and places of interest in England and abroad. However, not until 1874 was there a specific project to photograph London buildings. In that year Henry Dixon set up The Society for Photographing Relics of Old London with the purpose of recording buildings which were under threat of demolition. Over the next twelve years he produced 120 photographs which were issued to his subscribers as original carbon prints, each with accompanying text. Almost all those buildings have since vanished and his pictures are their only record.

By 1880 a number of methods of transferring photographs on to printing plates had been invented which resulted in the proliferation of photographically illustrated books. Of special note are the architectural books published by Batsford from 1891 to 1914 with soft photographic plates printed in collotype. Helmut Gernsheim's Beautiful London brings to a close what might be called 'the black-&-white' era.

There are several lessons to be learned from the books, prints and photographs mentioned in this brief survey. The work of artists and craftsmen recognizes no national boundary and the way historians, architects and artists view the past changes from generation to generation; in many cases books outlast the buildings they describe and illustrate. Also, and some may take comfort from this, all buildings are, in essence, temporary, and even those which survive do so only in part, their foundations underpinned, their interiors changed and their exteriors replaced again and again as they wear away.

We see also that architects concerned with restoration have a different view of the past from their predecessors, and are themselves so convinced of the correctness of their own interpretation that they engender anger and frustration in those that follow after them (ensuring a continuing livelihood for writers and publishers of books on architectural history). This ever-changing attitude to buildings is not new and is well demonstrated by those who drew them. It is clearly seen when comparing early drawings of ancient Rome with those of the same buildings made in succeeding centuries, and in English architectural and topographical drawings from the reign of Elizabeth I to the present.

The photographer, no less than the graphic artist, shapes and reflects the vision of his time. Matthew, in the foreword to this book, remarks that he is always prepared to 'return for a better light'; in other words, when it accords with what he wishes to see.

To each of us London is different. 'Hell is a city much like London', wrote Shelley; while Wordsworth, 'Earth has not anything to show more fair'. To De Quincey its streets were an abyss of despair, to Dr Johnson it was worth living for. To Nikolaus Pevsner its buildings cried out to be catalogued, while to John Betjeman it was a city of railway stations, 19th-century churches and friendly suburbs. To Canaletto it was bathed in sunshine, to Whistler enveloped in mist. To Matthew Weinreb it has revealed unexpected vistas and intriguing details; to everyone it is 'the unique city'.

Ben Weinreb, 1993.

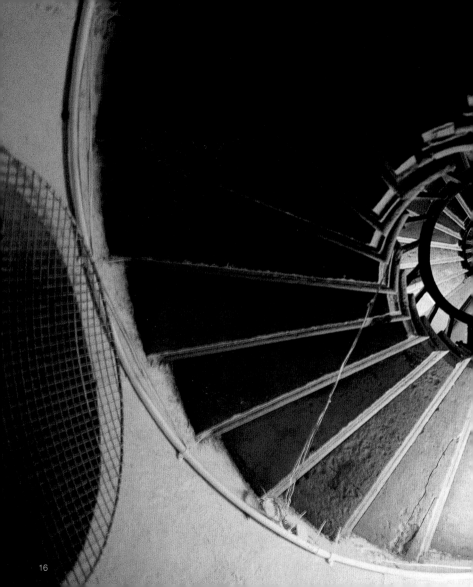

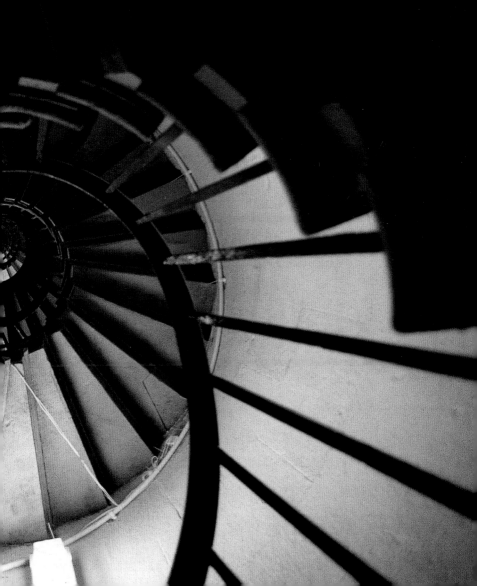

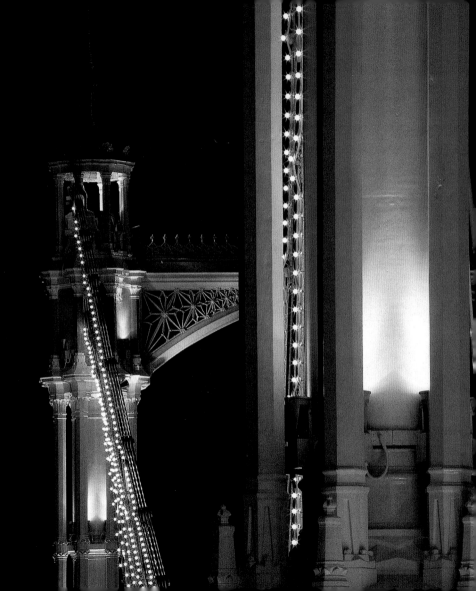

Metal

London is rich in historic ironwork – gates, railings, balconies and crestings. The earliest iron railings in front of London town houses were known as 'palisades' from their wooden predecessors, and date from the end of the 17th century. Such early railings were made of wrought iron. The malleability of this material made it highly suited to decorative ornamental work: the gate to the Fountain Garden at Hampton Court by Jean Tijou, of 1693, is an elaborate example.

The most common pattern for early 18th-century wrought-iron railings in London is of plain bars set into a stone plinth with a top rail. Ornament was usually confined to urn-shaped finials on the standards and perhaps a wishbone-shaped overthrow from which a lantern would be suspended to light the entrance.

Cast iron for railings was introduced in the early 18th century. Early cast-iron railings usually have heavy bars with spiked arrowheads such as those that remain round part of the enclosure of St Paul's Cathedral. Cast iron was produced at an increasing rate from the 1760s by large foundries in Scotland and Shropshire, and an architect quick to take advantage of this was Robert Adam, who designed cast-iron balconies and railings for the Adelphi development of the 1770s. In the Regency period cast iron largely replaced wrought iron as the chief material for making railings, splendid examples of which can be seen around Regent's Park, in Bloomsbury and in South Kensington.

Early railings were probably painted blue or grey; green was popular throughout the 18th century; while black was used during most of the 19th century. Gilding was reserved for grander town houses.

From the mid-19th century mild steel was manufactured as a cheaper alternative to iron, and the use of mild steel for external metalwork, with its smooth, even appearance, gradually began to rival that of iron, superseding it after the First World War.

Albert Bridge in Pimlico was named after the Prince Consort. This three-span bridge was designed by the engineer R M Ordish between 1871 and 1873, using his straight-link suspension system.

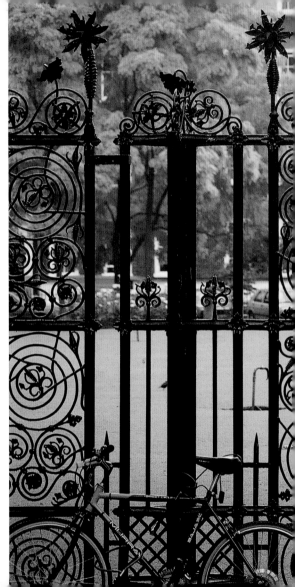

Above Railings off Harley Street, Marylebone.

Right The Brewster Gates, Lincoln's Inn, Holborn. These intricately crafted wrought-iron gates of 1872, were designed to commemorate Lt Col W B Brewster, first commanding officer of the Inns of Court Volunteer Rifle Corps.

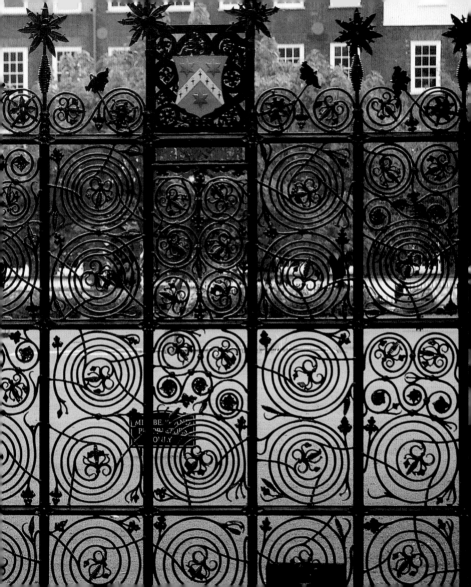

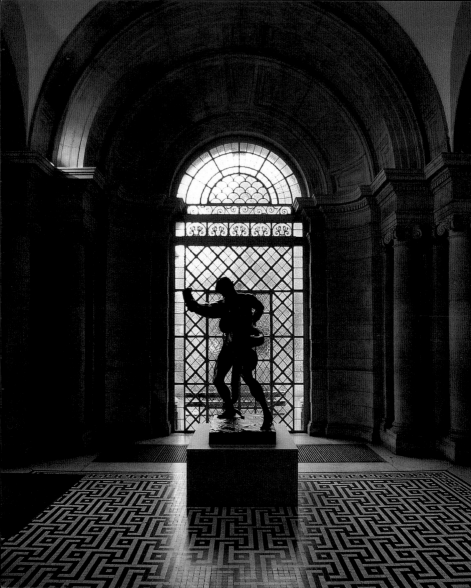

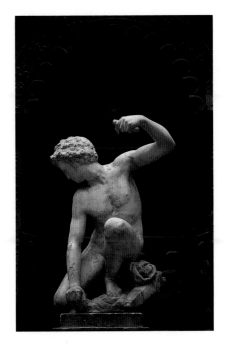

Far left The interior of the Tate Gallery built on the site of the Millbank penitentiary. Opened in 1879, the gallery was paid for by the sugar magnate Sir Henry Tate.

Left A sculpture in the Victoria & Albert Museum, South Kensington.

Above The main facade of Fenchurch Street Station, the City. The first railway terminus in the City of London, the station was built to serve the London & Blackwall railway, opened in 1841. This facade is of part of the new 1854 station designed by George Berkeley.

Left Canary Wharf Station and Tower, Docklands.

Following pages 26/27 Ornamental porticos after Michelangelo and others from the Brompton Oratory, South Kensington **(26 top)**, the London School of Anatomy, Bloomsbury **(26 bottom)**, Lombard Street, the City **(27 top)**, and Westminster **(27 bottom)**.

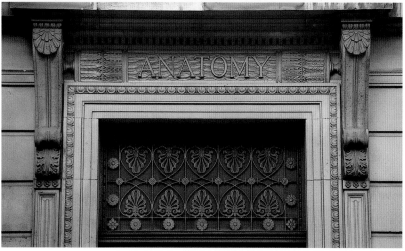

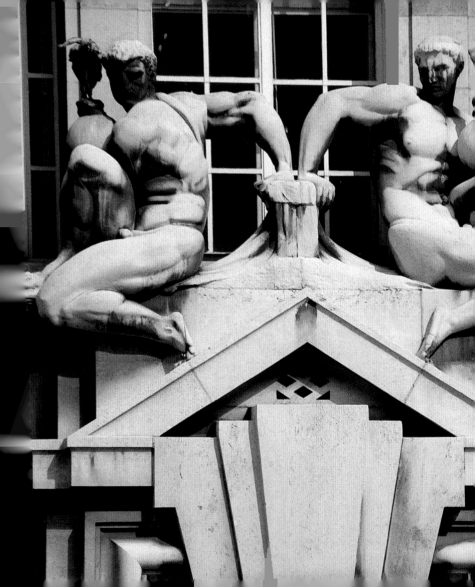

Architectural sculpture

Architecture and sculpture, the preeminent arts of the classical world and the Gothic, became increasingly entwined during the 19th century. Palladianism had banished sculpture to pediments and parapets, but Victorians reversed this and soon muscular men and semi-draped maidens peopled the capital's buildings.

Sculpture confers status upon a building. Its presence endows it with art and meaning, enabling its purpose and aspirations to be identified. Allegorical figures are identified by their attributes: Justice on the Old Bailey by Frederick Pomeroy, of 1906, carries her scales and sword, while opposite, a former railway office building has a Portland stone woman with a locomotive in her lap. Around 1840, winged Gothic angels replaced Baroque cherubs in stating the religious purpose of a church or school.

New opportunities for sculptors arose as Victorian eclecticism developed. Edwardian architects, such as Beresford Pite and John Joass, rediscovered the mannerism of Michelangelo: his muscle-bound figures of Day and Evening which recline so languidly in the Medici Chapel of San Lorenzo, were the models for a multitude of figures over the doors and windows of London's grandest buildings. Ralph Knott's County Hall, started in 1909 as the headquarters of the London County Council, sports a wealth of architectural sculpture. Many of the leading architectural sculptors were trained in the Lambeth School of Art.

The rebuilding of the Bank of England by Sir Herbert Baker in the 1930s was the last notable marriage of architecture and sculpture. Charles Wheeler, the sculptor responsible, regretted the passing of the phase, but took solace from the fact that his audience consisted of no less than the entire population of the metropolis.

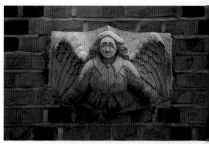

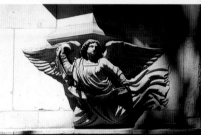

Left Inspired by Michelangelo's Medici tombs in Florence, these monumental sculpted figures adorn the external facade of the main building of County Hall in Westminster, built by Ralph Knott and completed in 1922.

Top: A sculptural detail from the former St Marylebone Grammar School on Marylebone Road.

Above: A carved stone angel from the Roman Catholic Church of the Immaculate Conception on Farm Street, Mayfair.

Following pages
30 Detail of a terracotta frieze and ornamental panel from the Victoria & Albert Museum, South Kensington.
31 A grotesque terracotta keystone from a pub in Fulham.

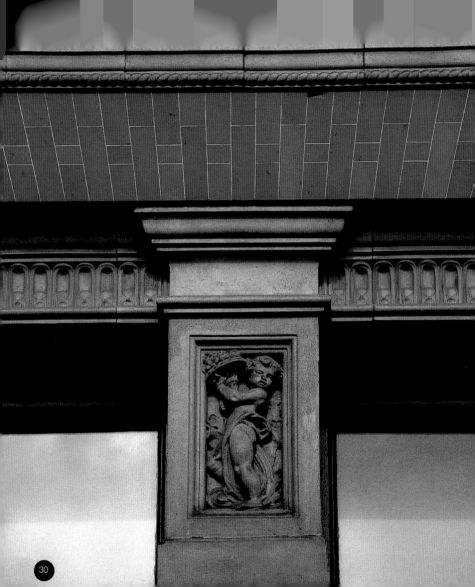

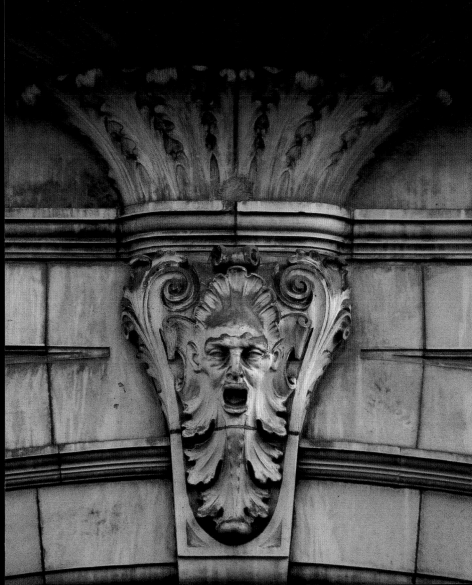

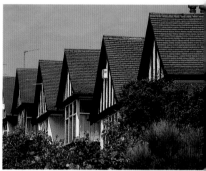

Above Mock Tudor but genuine Neasden.

Left Kensington Court, Kensington. These grand terraced houses, built in 1882 by J J Stevenson, are an early example of a housing scheme lit and heated by electricity supplied by a district electric power station.

Following pages
34/35 Leadenhall Market in the City. The third building on the site, this was designed by the City architect Horace Jones in 1881. A dead meat and poultry market, it is ventilated and elaborately decorated with glass and timber louvres.

36 A view along the central block of Cumberland Terrace with its giant order of Corinthian columns. Completed in 1828, this is the most splendid of John Nash's stuccoed terraces in Regent's Park.
37 The Elephant House of London Zoo in Regent's Park was designed by architects Casson and Conder, and completed in 1965. Its exposed concrete form displays an innovative ribbed and hammer aggregate finish.

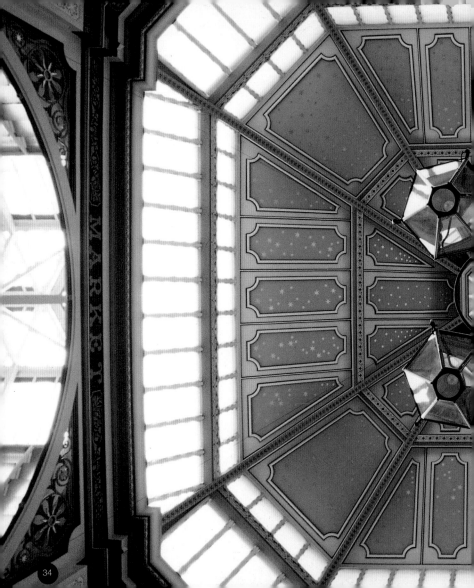

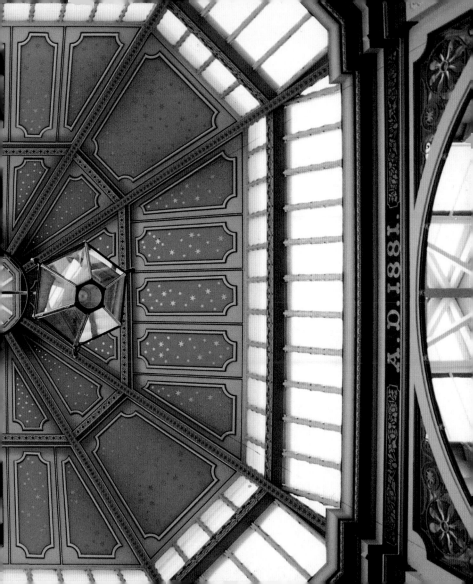

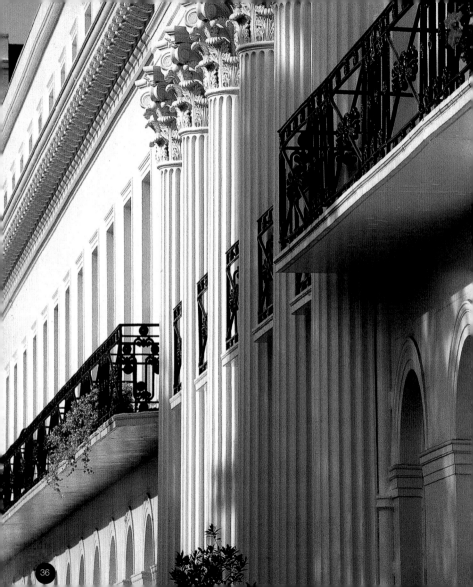

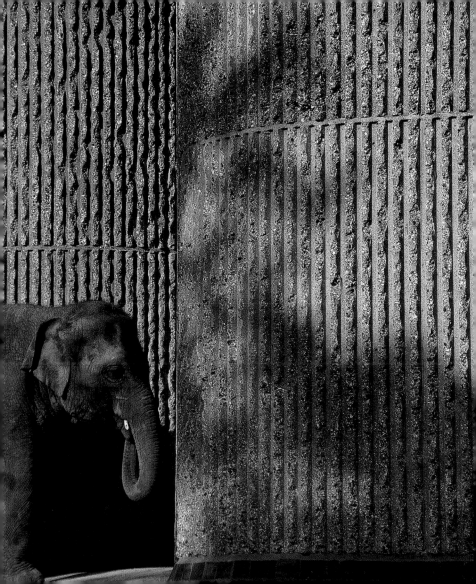

Stone

Unlike the stone-built cities of Edinburgh and Bath, London is built on clay and its stone has been carried in, first by water and ox-drawn wagon, then over metalled road and rail. The Romans used Kentish ragstone for London Wall, bringing it up the Medway in barges, as did the Normans for the White Tower, dressing it with limestone from Caen in Normandy; Caen stone was also brought across the Channel to build Old St Paul's. The sandstone quarries under the North Downs were another source, and provided the stone for the London Bridge of 1176 and Westminster Abbey.

However, Caen stone could not withstand the weather and, as Sir Christopher Wren complained, it was 'more beautiful than durable'. Likewise, Kentish rag 'takes in water, which, being frozen, scales off, whereas good stone gathers a crust, and defends itself'. Wren chose Portland stone in rebuilding London after the Great Fire of 1666, for though neither warm to the eye nor malleable to the hand, it was the best building stone in England; it could be quarried in large blocks, withstand the weather and was impervious to smoke and grime.

Portland stone was first brought to London in 1340. Inigo Jones had used it for the Banqueting House in Whitehall and for the Queen's House in Greenwich, but it was Wren who established it as London's premier building stone. He used over a million tons of it to build St Paul's Cathedral. Many London architects followed: Chambers for Somerset House, Hawksmoor, Gibbs, Soane and even Lutyens, through to the present day. Although Portland stone predominated, other stones were introduced: magnesian limestone for the Houses of Parliament, York stone for paving, and granite for kerbstones, setts and for Nelson's Column. Today, the Portland stone of Regent Street distinguishes it; the walls, washed whiter than when the stone was freshly cut, still declare their precedence over the browns of London brick.

The columns on the octagon base supporting the cupola which crowns Aston Webb's main facade of the Victoria & Albert Museum, South Kensington.

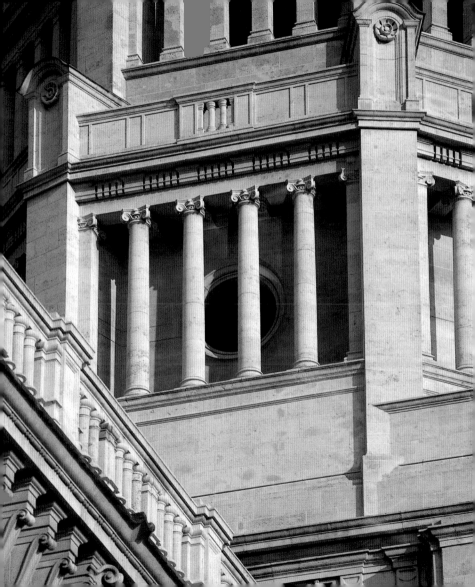

Porticos with
decorative elements
in Shenley Village,
Hertfordshire,
of 1863 **(above)**,
and Upper Street,
Islington **(right)**.

Following pages
42 Offices near
St Paul's Cathedral
in the City.
43 A 19th-century
riverside warehouse
with external
loading doors at
each level,
Southwark.

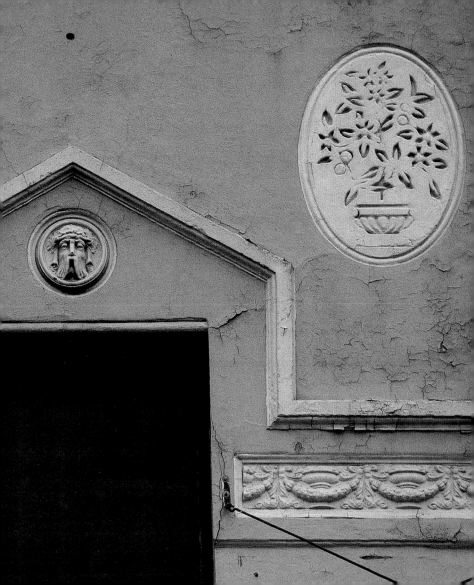

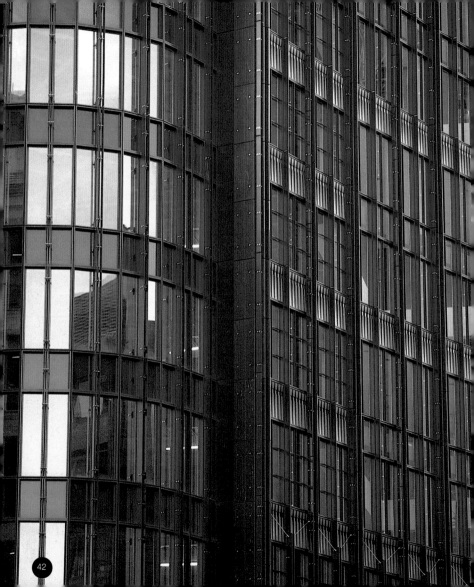

Blackfriars Bridge in the City. The bridge's name derives from the ancient Blackfriars Monastery founded in 1221.

Following pages
46/47 The interior of the City's Liverpool Street Station. The terminus of the Great Eastern Railway, this part of the building was designed by Edward Wilson and the ironwork, including these cast-iron columns with their foliate decoration, were fabricated by the Fairburn Engineering Company based in Manchester.

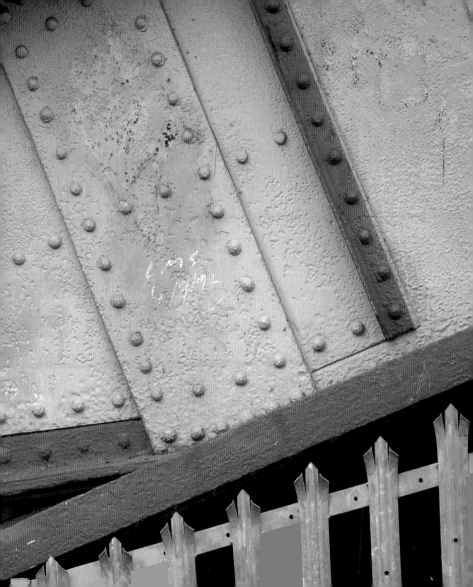

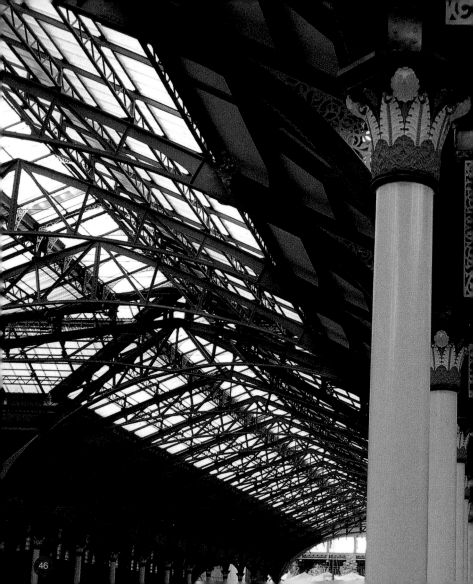

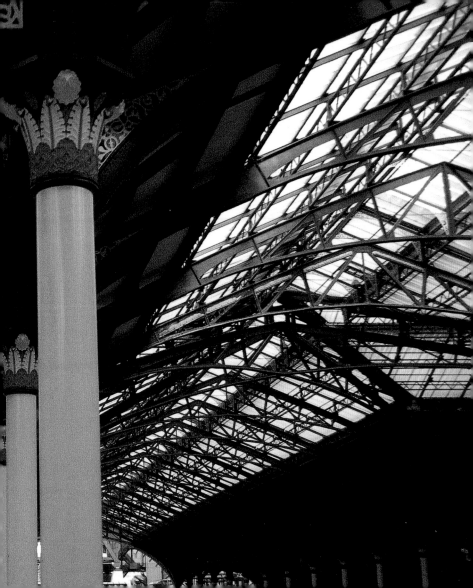

Balconies

Perhaps because of the inclement weather, balconies tend to feature less in architecture in England than in southern Europe. The first instance of full-blooded emulation of the balconies on the façades of Italian palaces and villas is the Queen's House in Greenwich by Inigo Jones, begun in 1619. Balconies began to enjoy a more general vogue in London from the 1760s. No 7 Adam Street designed by Robert Adam in 1773 bears two handsome balconies made of cast iron, but with a pattern resembling the elaborate precursors in wrought iron. From about 1820, balconies appeared in large numbers, often selected from designs in pattern books. So sweeping was the fashion for a first-floor balcony, that existing windows were frequently elongated to give out on to balconies overlooking the street, or, as at the Nash terraces around Regent's Park, a communal garden and the park beyond.

Balconies enjoyed a revival in the health-loving 1930s: Tecton's cantilevered 'sugar lumps' at Highpoint in Highgate and Maxwell Fry's Sun House with open and sheltered balconies are jolly examples. In the post-war period, balconies became a common feature on the large-scale housing estates, and sham balconies were sometimes set alongside genuine projections for the sake of a geometric pattern. The balconies on the towers at the Barbican are treated in a more three-dimensional, sculptural way.

The London balcony still has life and invention in it. Interesting new examples of the feature are incorporated in the Villiers Street side of the new station at Charing Cross by Terry Farrell completed in 1991.

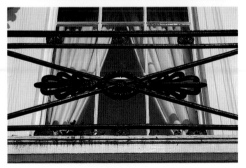

London balconies, including those at Highpoint **(left)**, in Highgate, which were designed by Berthold Lubetkin and Tecton in 1936 following the precepts of Le Corbusier.

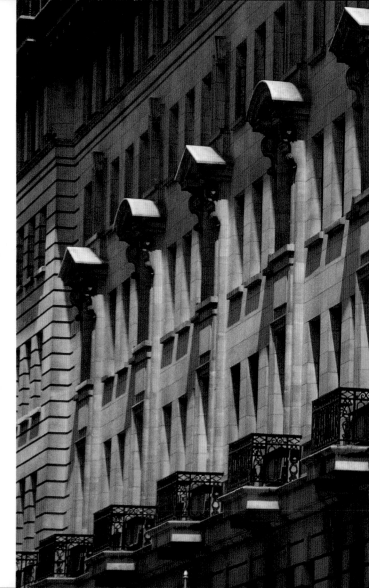

Chiltern Court on Baker Street, Marylebone. A block of flats designed by the architect C W Clark around 1912 for the Metropolitan Railway and built over Baker Street Underground Station.

Following pages
52/53 Aston Webb's entrance portal to the Victoria & Albert Museum in South Kensington; inspired work in terracotta.
54/55 The facade of the Palace of Westminster or Houses of Parliament. It is built on the site of Edward the Confessor's ancient palace, the main residence of the kings of England until 1511, and the seat of government until 1834 when it was largely destroyed by fire. Sir Charles Barry and Augustus Welby Pugin were the architects responsible for the new and greatly enlarged neo-Gothic buildings erected between 1837 and 1860.

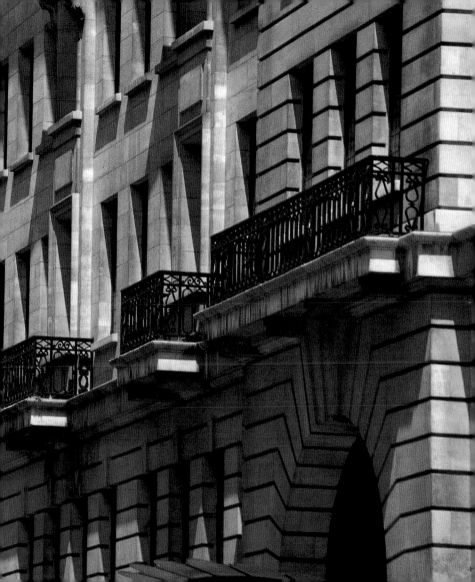

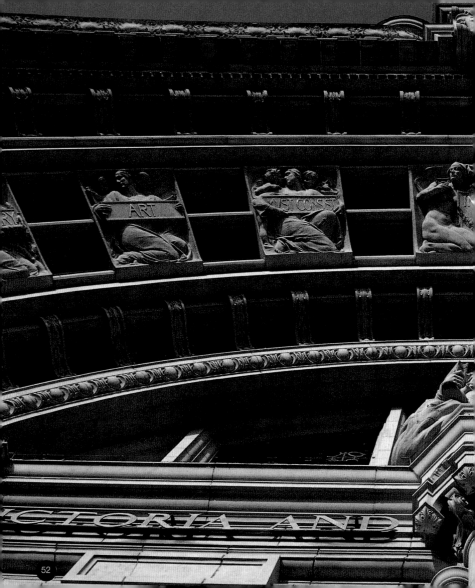

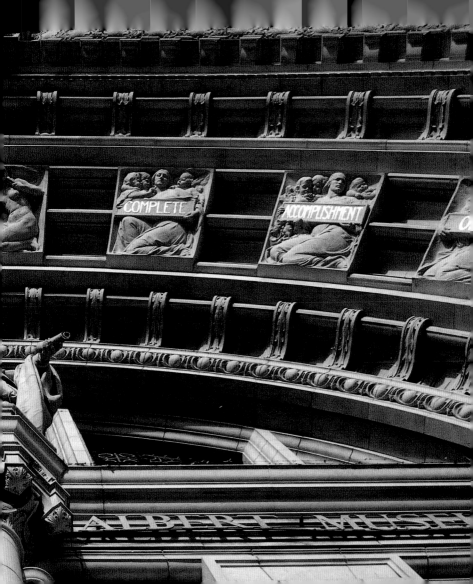

COMPLETE ACCOMPLISHMENT

ALBERT MUSE

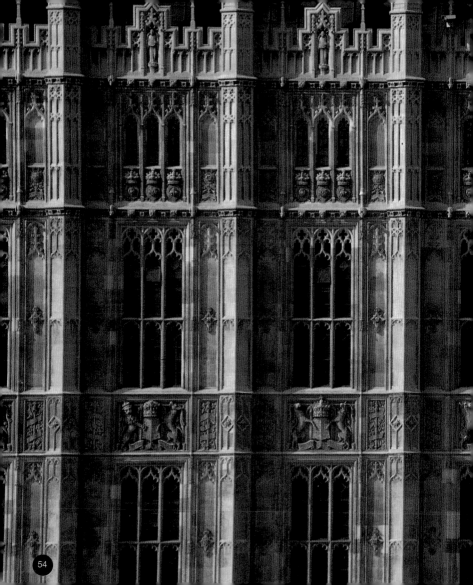

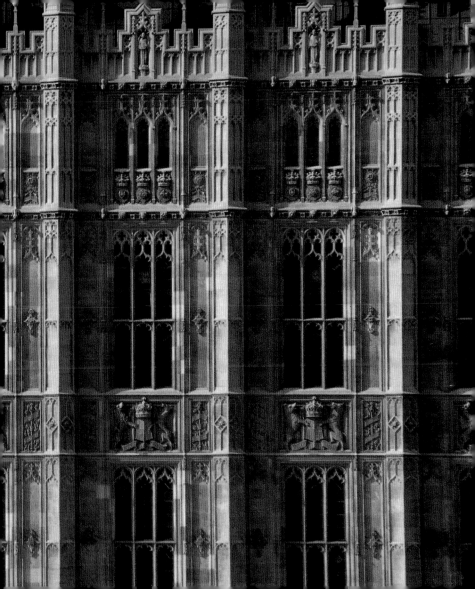

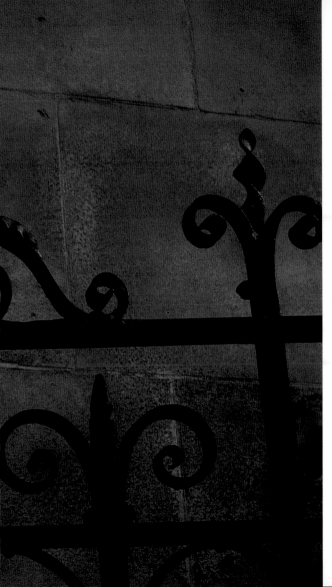

Above A sundial on Cheapside in the City.

Left The railings of the Brompton Oratory in Knightsbridge.

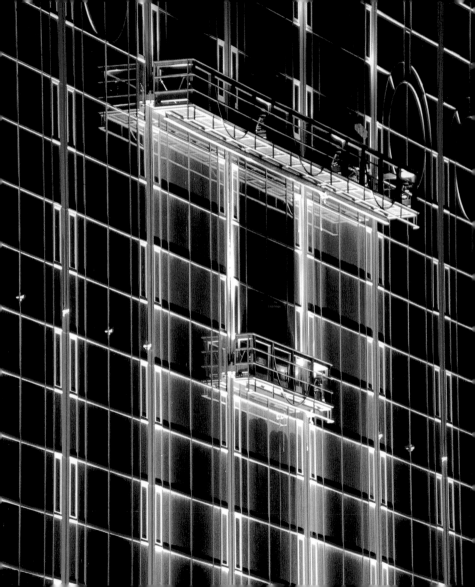

Iron and glass

'Iron is the soul of a building', wrote the French architect Charles Eck, a statement as true for Britain as for France. Iron is the hallmark of 19th-century architecture and it changed the scale of building. Immense roof and floor spans became possible, while thin wrought-iron glazing bars allowed greater expanses of glass; all exemplified in some of the foremost public buildings in London.

In the 1820s, Robert Smirke used long-span, cast-iron beams for the roof of the British Museum's King's Library, as did Nash in Buckingham Palace. Nash again turned to cast iron, stuccoed to look like stone, for the giant fluted Doric columns on the Mall frontage of Carlton House Terrace. Sir Charles Barry, too, made extensive use of cast iron to achieve long spans at the Travellers' and Reform Clubs on Pall Mall, and for the roof of his Houses of Parliament (including roof cladding, smokestacks and dormer windows) for the purposes of fireproofing.

While architects began to exploit cast iron, J C Loudon introduced the idea of glazing bars in wrought iron, which could be rolled into thin sections and bent to flowing curvilinear forms for glasshouse construction. A dramatic and beautiful example of what could be achieved is Decimus Burton's magnificent Palm House at Kew Gardens.

Cast iron, wrought iron and glass came together felicitously in Joseph Paxton's Crystal Palace of 1851. Although it no longer stands, this same fruitful relationship is still to be seen in the great trainsheds at Paddington and Liverpool Street stations with their wrought-iron and glass roof structures springing from elegant cast-iron columns.

Very large interior public spaces were also made possible by the use of such iron and glass roof structures; notable examples include the Reading Room of the British Library, the Royal Agricultural Hall in Islington, the Olympia Exhibition Hall and, most impressive of all, the vast elliptical volume of the Royal Albert Hall.

An office block
in Brentford.

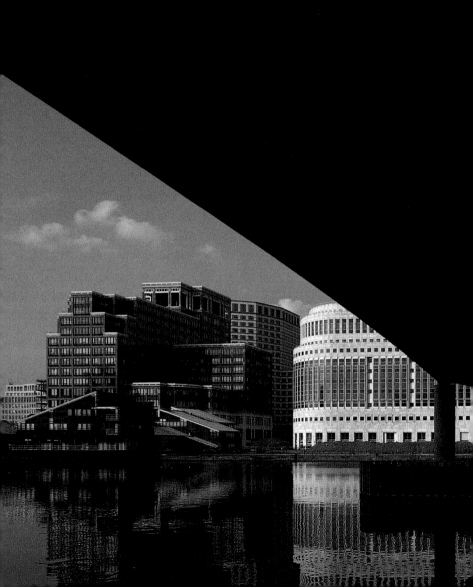

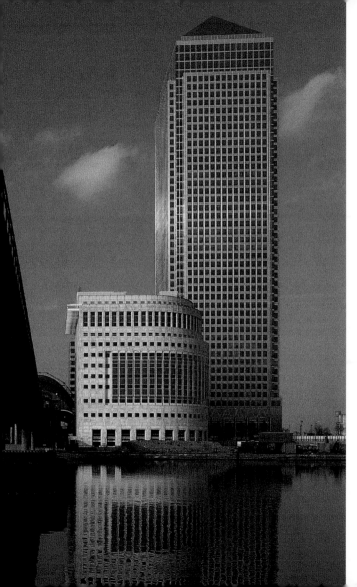

A view of Canary Wharf across West India dock. Canary Wharf stands on the Isle of Dogs which became the site for London's first system of wet docks at the turn of the 19th century. Intended to become a major business centre, it is modelled on two previous property developments by Olympia and York in Toronto and New York.

Following pages
62 The copper-clad clock tower of Walthamstow Civic Centre, Walthamstow, completed in 1942.
63 Big Ben, the most famous tower of the Palace of Westminster or Houses of Parliament. The name 'Big Ben', familiar throughout the world, is properly applied to the bell which is named after Sir Benjamin Hall, First Commissioner of the Works when it was hung in 1858. The clock was designed by E J Deut and the bell by George Mears of the Whitechapel Bell Foundry.
64/65 Office buildings in Marylebone **(64)** and Westminster **(65)**.
66/67 The entrance hall of the Natural History Museum in South Kensington with its Romanesque-style arcades supporting an iron and glass roof. It was designed by Alfred Waterhouse and completed in 1881.

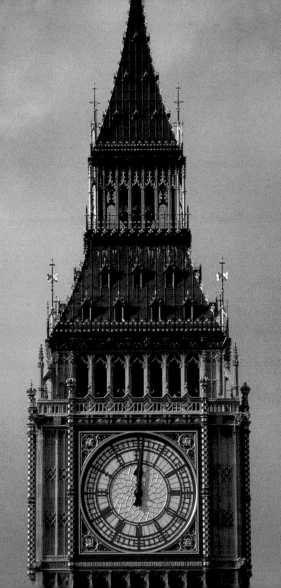

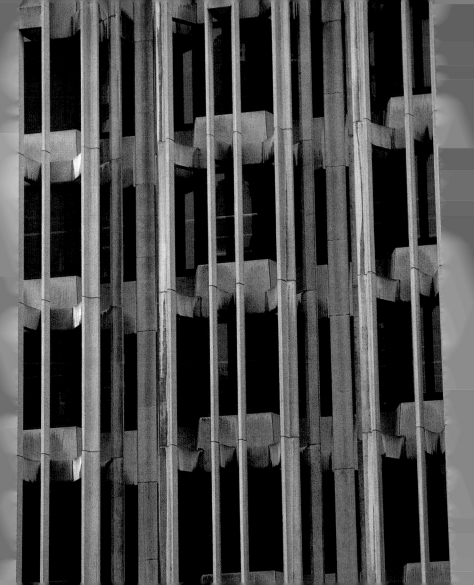

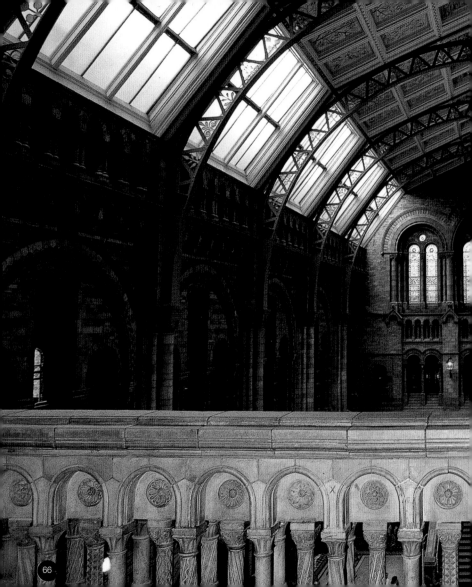

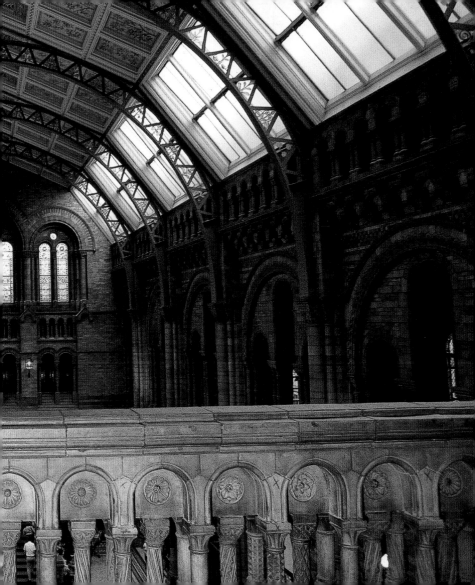

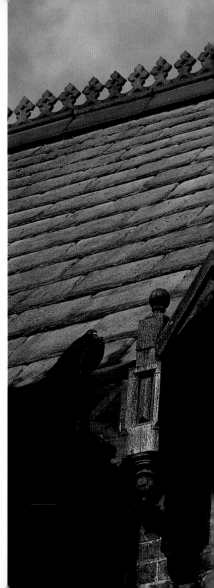

Roofs and gables

Four hundred years ago, before brick and stucco began to supplant timber construction, every London street was a sequence of gable ends, jettied perilously until they almost met in the narrower streets. Most surviving examples have been reconstructed, such as Staple Inn, Holborn and Prince Henry's Room, Fleet Street.

The later Georgians did not like the look of roofs and started to replace tile with Welsh slate, which meant lower pitches behind parapets and an end to the high pent roofs of houses until then. The Gothic Revival brought back roofs and gables, sometimes at a steeper pitch than ever. The French-style mansard rooftops of Grosvenor Gardens were the *ne plus ultra* of London slating. But the heyday of the London gable came with the Queen Anne Revival of the 1880s and 1890s, when first houses, then libraries, baths and pubs broke out into steps, scrolls and mini-pediments. Later roofs are a come-down after these, but the plunging parabolas of some 1960s buildings, like the Commonwealth Institute, give a taste of what we might have if architects were once again courageous with their roofs.

Above Verona in Kentish Town. A goose-stepped brick and terracotta gable, Kentish Town Baths, Prince of Wales Road, Kentish Town.

Right One of a group of eight rustic Gothic cottages in Holly Village, Highgate, built in 1865 by H A Darbishire for the servants of the philanthropist, Baroness Burdett Coutts, who founded many of the orphanages and refuges throughout London.

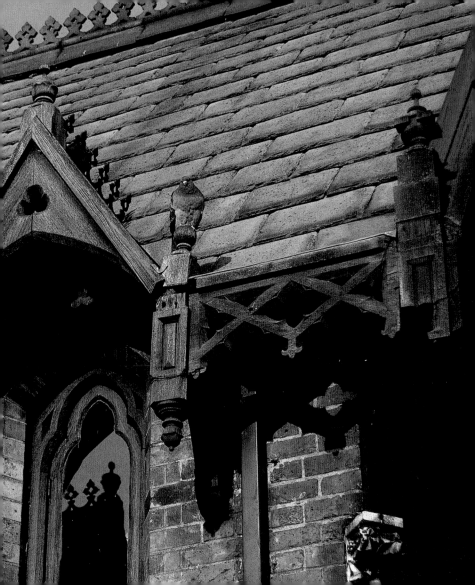

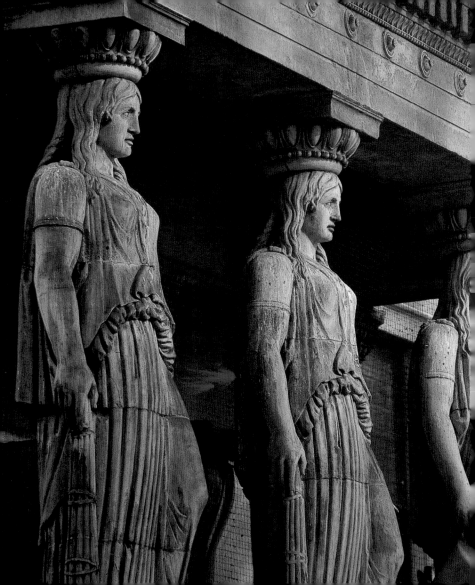

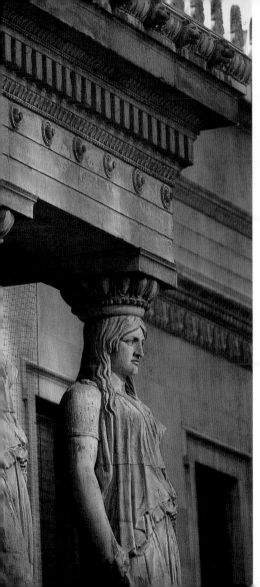

Entrance portals in the Borough **(top)** and Gower Street, Bloomsbury **(above)**.

Left St Pancras Church on Euston Road, Marylebone. Designed by architects H W and W Inwood and completed in 1822, it is the earliest Greek Revival church in London. Its most prominent feature is the copy of the portico of the caryatids from the Erechtheum in Athens; the Greek originals are in stone, but the London versions are in terracotta over a cast-iron core.

Following pages 72/73 The principal elevation of Robert Adam's Kenwood House in Highgate, completed in 1764. Its two white brick wings were added by George Saunders in 1796.

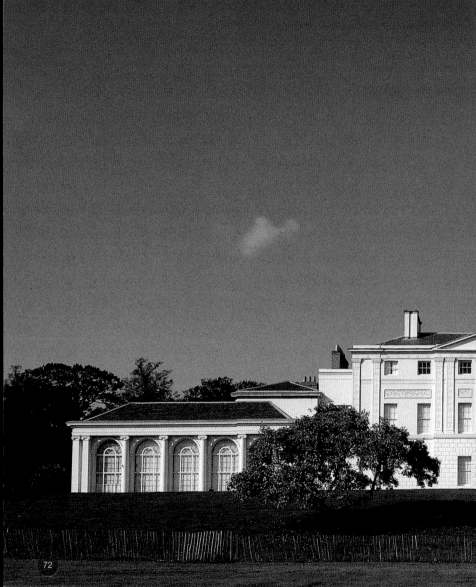

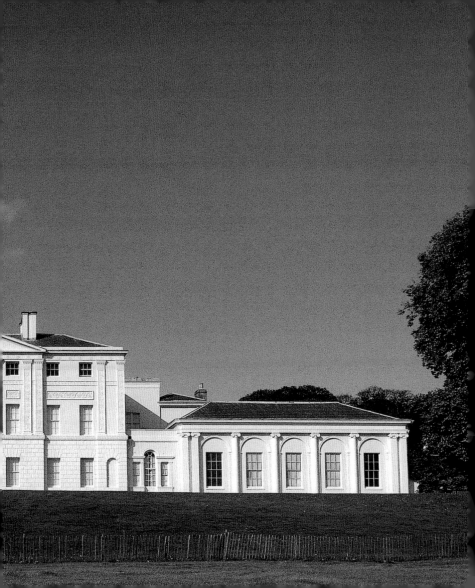

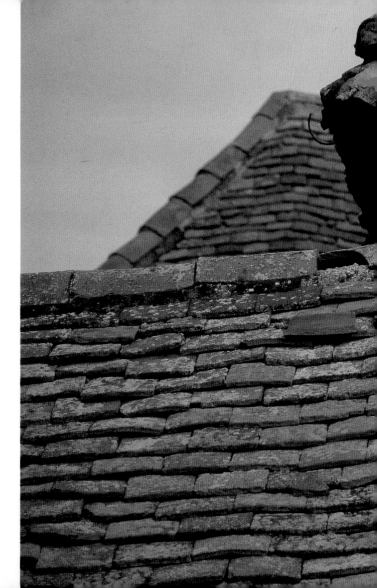

A roof detail
from a stable at
St Margaret Ridge,
Hertfordshire.

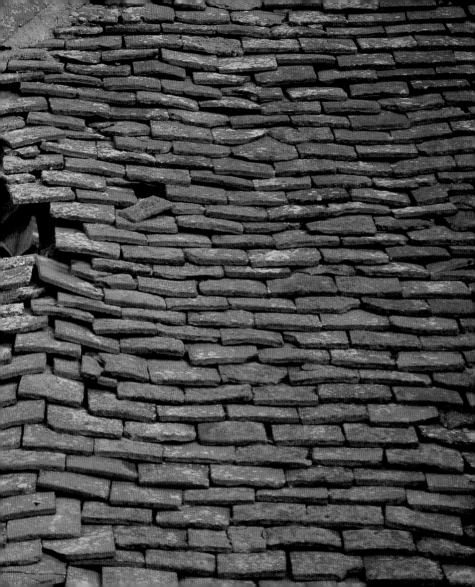

The half-timbered porch of the Parish Church of St Margaret Ridge, Hertfordshire, infilled with knapped flints and displaying highly decorative barge boards **(top left)**; a rusticated doorway in Coade stone situated beneath the main exterior stairs of Chiswick House, designed by Lord Burlington and completed in 1729 **(bottom left)**; a doorway in Marylebone **(top right)**; a garden doorway in Chiswick Mall, Chiswick **(bottom right)**; and an entrance door in Grosvenor Square, Mayfair **(far right)**.

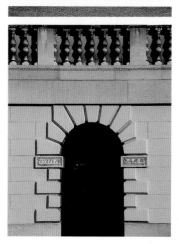

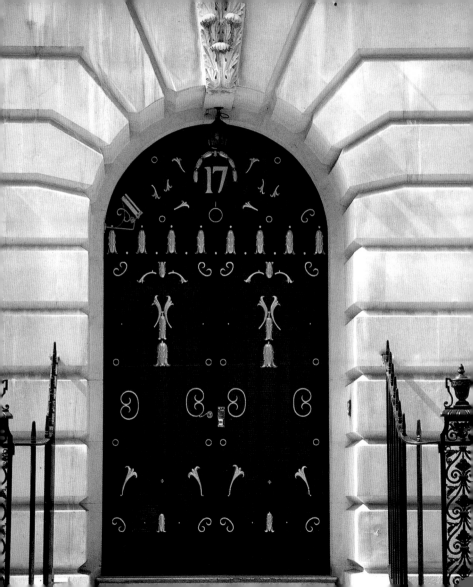

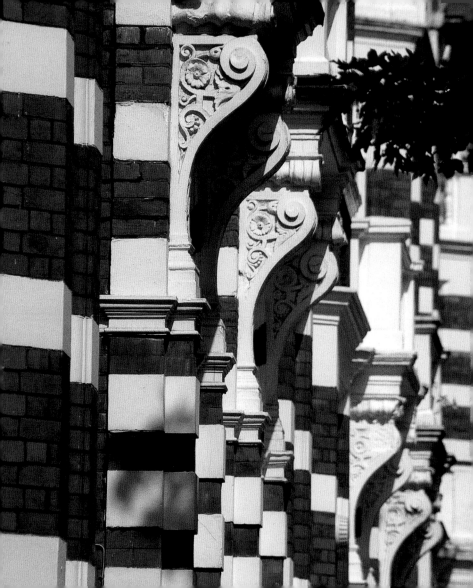

Brick

London is a city of brick. 'It is not only more comely and durable but more safe against future perils of fire...' decrees the 1666 Act of Parliament for the rebuilding of London, which continues '...that all the outsides of all buildings in and about the said city... be henceforth made of brick or stone...'. Eton College had been built of brick by 1452, and Hampton Court soon after. But by the time of the Great Fire, the majority of houses were still of wood. 'I up to the top of Barking Steeple and there saw the saddest sight of desolation that I ever saw,' wrote Samuel Pepys the day after the fire.

Domestic needs were met by itinerant brick makers who set up their pub-mills, clamps and kilns wherever suitable deposits of clay were uncovered, whilst the huge quantities required by Wren and Hawksmoor for their major projects were produced by master brick makers. Not only were rough bricks needed for the infrastructure of their stone buildings, but marl, stocks and place bricks were required in even larger numbers for the facings of buildings. Marl is of bright uniform yellow, while stocks are either red or grey and all had to be made to standards of strength, texture and colour. The quality of English bricks was matched by the craftsmanship with which they were bonded together, either to the English or Flemish pattern.

The fine tradition of English brickwork lasted into the early 19th century, but by the late 1850s the demand for cheap building materials to house an expanding working population led to the mechanization of brick-making. Thus the subtle modulations of bricks, once hand moulded on a wooden stock, gave way to a dull uniformity. Recently attempts have been made to produce again bricks of warmth and beauty, by mixing into clays the salts and sands of early bricks. Good bricks have the best of human qualities: they are not puffed up, they beareth all things, endureth all things and do not behave themselves unseemly.

Mansion flats
in Maida Vale.

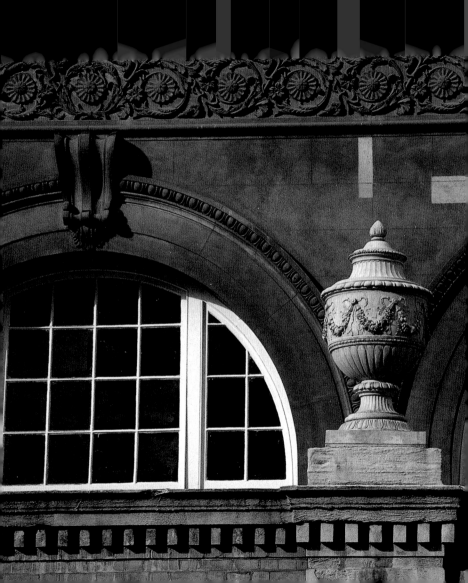

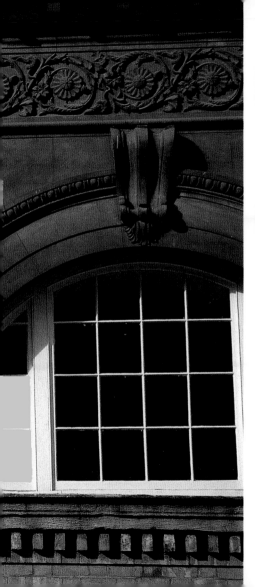

A fanlight with graceful tracery on Queen Anne's Gate, Westminster **(top)**, and a fanlight with terracotta surround, from University College Hospital, designed by Alfred Waterhouse and completed in 1906 **(above)**.

Left An ornamental urn on the stables of Buckingham Palace.

Following pages
82 Sir Christopher Wren's majestic entrance colonnade to St Paul's Cathedral in the City, built between 1675 and 1711.
83 John Nash's giant columns on Cumberland Terrace in Regent's Park completed in 1828.

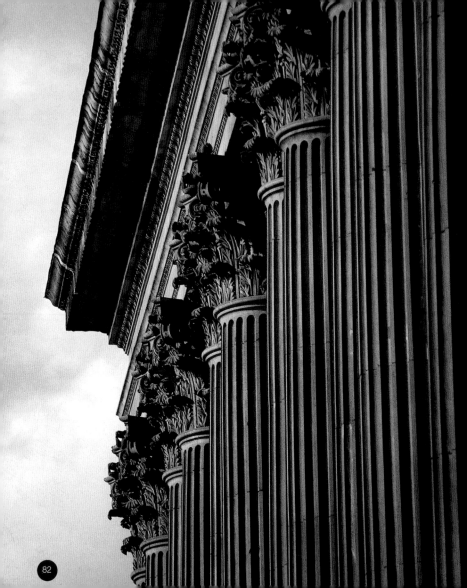

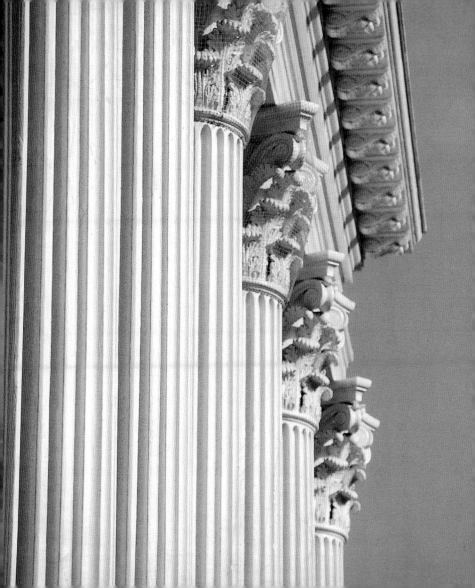

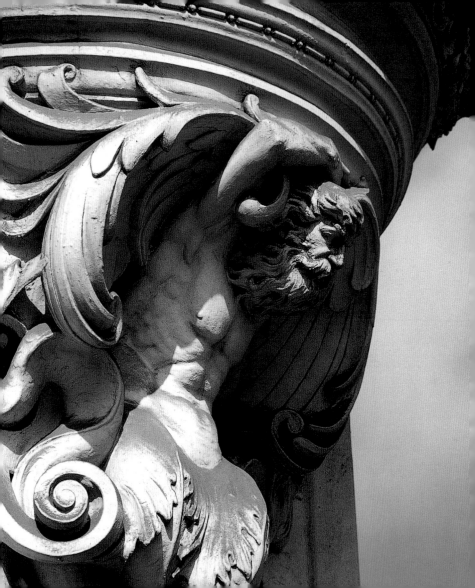

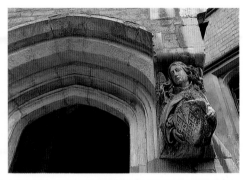

Decorative corbels from Tottenham Court Road, Marylebone **(far left)**, Westminster Abbey Buildings **(top)**, Queen's Gate, Knightsbridge, **(left)**, and Dean's Yard, Westminster **(above)**.

Following pages 86/87 The front elevation of the Royal Hospital, Chelsea. Designed by Sir Christopher Wren, Nicholas Hawksmoor and Sir John Vanbrugh, it was built between 1681 and 1691 to house army veterans. A Tuscan stone portico stands at the centre of the long brick facade.

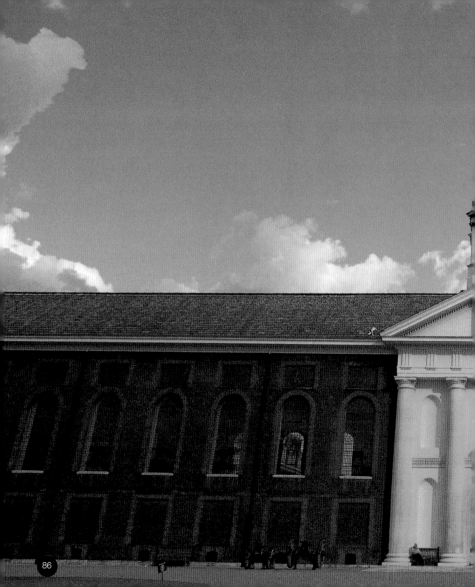

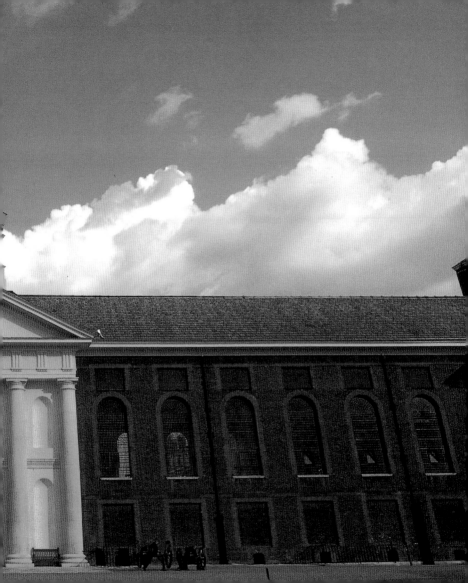

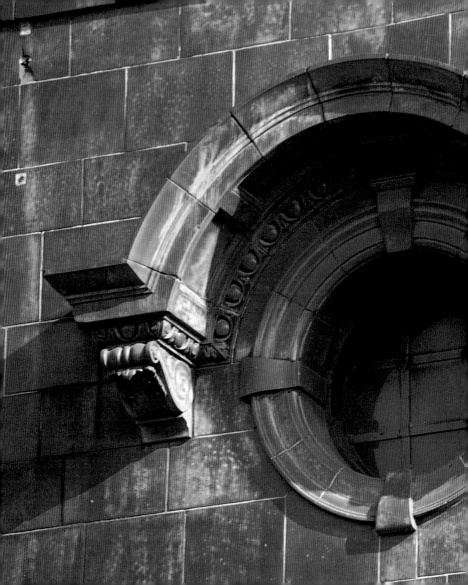

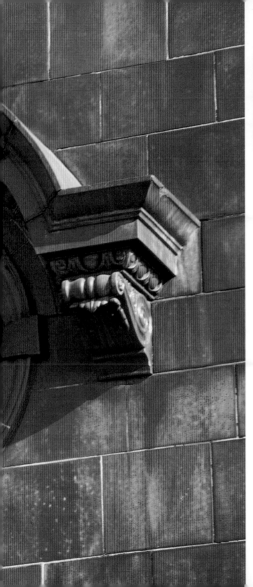

Windows

Windows are a good guide to the age of a building, nowhere more so than in London. Even the sash window, almost universal from its importation from northern Europe in the 1690s until the 1850s, evolved in a series of definable phases. These are demarcated by a series of Building Acts, introduced after the Great Fire of 1666 to control the combustible material on London's façades. The sash window comprises two vertically-hung panels made up of a series of panes, their opening controlled by balanced weights hidden in boxes to either side. The 1709 Act required that windows be set behind the facade, the 1774 Act that the sash boxes be concealed within the brick-work; this last confirmed an already developing fashion.

Cheaper availability of larger pieces of glass from the early 19th century spurred greater variety in design, pushing glazing bars to the margins and from the late 1840s eliminating them completely. Later, the Queen Anne movement saw more variety in sashes, with large panes below and tiny, picturesque ones above. Shapes also became more inventive. There are few elements more evocative of their style than the roundel window is of Edwardian Baroque, or the horizontal metal casement set round a corner of 1930s 'moderne'.

Previous pages

88 A hooded bull's-eye window from King's Cross Underground Station.

89 A shuttered window in Kensington.

A plate-glass shop-front with glazed tile surround in Notting Hill, Kensington; a typical feature of this part of London.

Following pages

92/93 Oxford Street's Selfridges was built on the American pattern for the entrepreneur Gordon Selfridge by R F Atkinson and F S Swales, with contributions by Daniel Burnham. It was one of the first buildings in London to be constructed with a steel frame, and the Ionic order on the facade is based on Philibert de l'Orme's Palais des Tuileries in Paris. The ironwork was supplied by Macfarlane's of Glasgow.

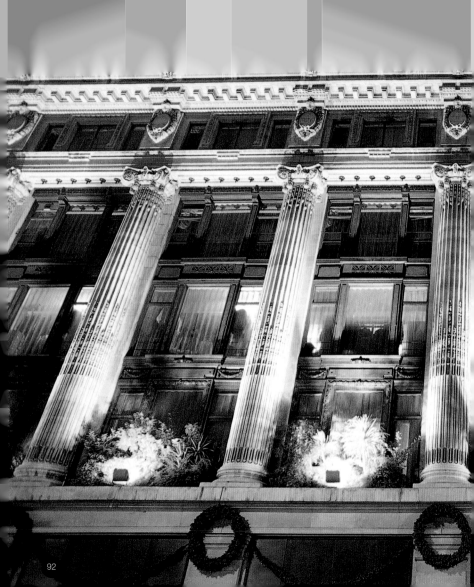

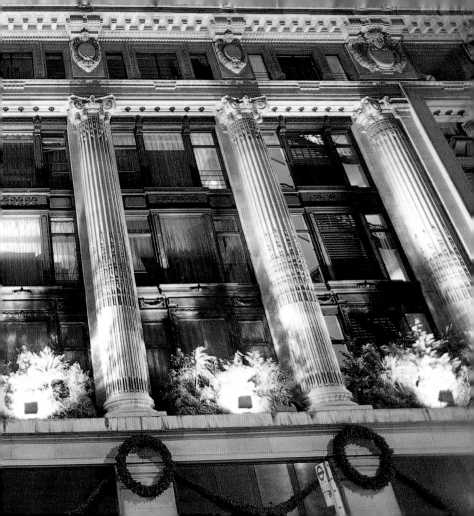

Right The London
Hippodrome,
Leicester Square, was
designed in 1900 by
Frank Matcham, one
of London's greatest
and most prolific
theatre designers,
and built in the
Flemish Renaissance
style. The building
is surmounted by
an open work iron
crown supporting
a two-horse chariot
and gladiators.

**Far right and
opposite** Two domes
in the City with
oculi decorated in
the classical manner.

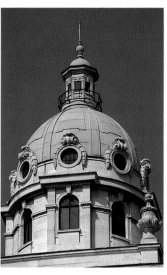

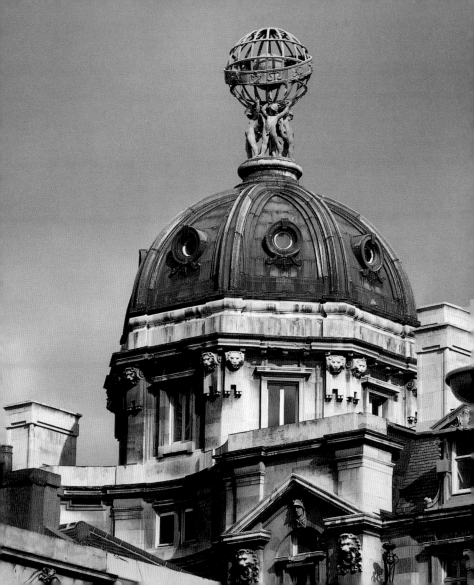

An ornamental terracotta surround from the Royal Albert Hall, South Kensington **(above)**, and the impressive bronze entrance doors to the RIBA (Royal Institute of British Architects) in Portland Place, Marylebone, designed by the architect Grey Wornum in 1934 **(left)**.

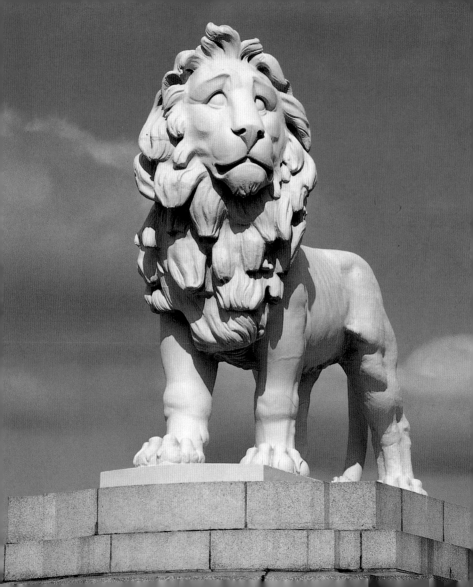

Coade stone

In 1769 Eleanor Coade set up her 'LITHODIPYRA MANUFACTURY' at Narrow Wall, Lambeth. Although there had been artificial stone from Roman times, Mrs Coade with her carefully guarded formula produced the most durable and satisfactory 'moulded stone' of all time. We know from recent analysis that it was made from ball-clay, flint, fine sand and soda lime-silicone glass, fired and ground down, then pressed into specially prepared moulds, released and fired again. Hence 'Litho-di-pyra', the joining together of the Greek words meaning: stone, twice and fire.

Eleanor Coade was a formidable business woman. During her long life she executed commissions for the leading architects in Britain including Adam, Chambers, Wyatt, Nash and Soane. She herself employed highly skilled sculptors, artists and draughtsmen, the most famous of whom was John Bacon, and made many statues and friezes to the designs of John Flaxman, E H Bailey and Thomas Banks. Like her contemporary Josiah Wedgwood, she copied and adapted statues, vases and ornaments from antiquity, using for reference the illustrated folios of the period. With her partner John Seely, she built a gallery at the Lambeth end of Westminster Bridge to display the full range of their wares. The exhibits were embellished with quotations from classical authors, duly translated. A copy of the 1799 illustrated catalogue and guide to the gallery is preserved in the British Library.

Mrs Coade died in 1821. For a further twenty years, the factory fought a losing battle against terracotta architectural ornament from the potteries, and with its demise, the secret formula was lost. Today, several hundred examples survive, not only in London, but also throughout Britain and as far afield as Washington, Montreal, Gibraltar and even Rio de Janeiro. They are a reminder of the elegance and beauty of the Classical Revival, as well as a monument to the perception, style and enterprise of a remarkable woman.

The South Bank Lion. This is the most famous of the Coade stone lions by William Waddington. First erected in 1837 over the Lion Brewery facing the river in Lambeth, it was moved at the time of the Festival of Britain in 1951 to its present position on Westminster Bridge, not far from the site of Mrs Coade's gallery.

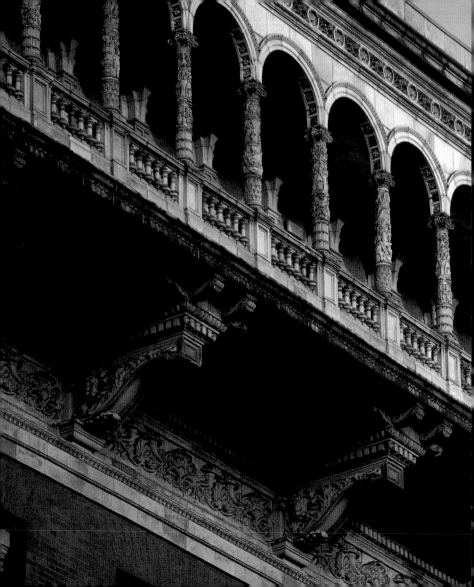

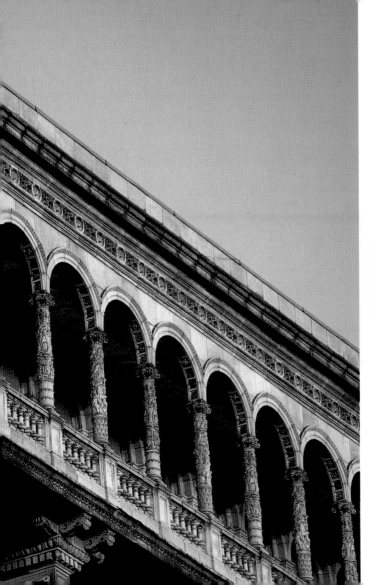

The arcaded brick
and terracotta loggia
of the late 1860s,
designed by
the Royal Engineer
Henry Scott, which
now forms part
of the Henry Cole
Wing of the Victoria
& Albert Museum,
South Kensington.

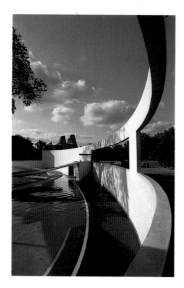

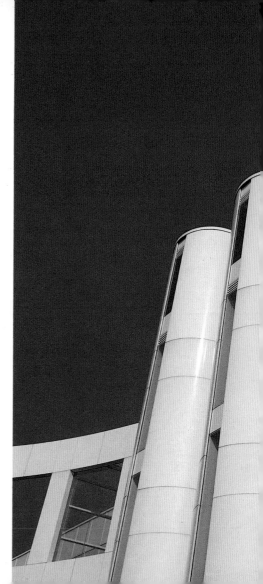

Above The Penguin Pool at London Zoo, Regent's Park. Built by architects Lubetkin and Tecton in 1935, this is a dramatic example of 1930s avant-garde architecture made possible by reinforced concrete.

Right An office building in Stockley Park, Heathrow, by Arup Associates. This new business park is a showcase for modern architecture.

Following pages 104/105 The high point of terracotta architecture exemplified by buildings in South Audley Street, Mayfair **(104)** and the Natural History Museum, South Kensington **(105)**.

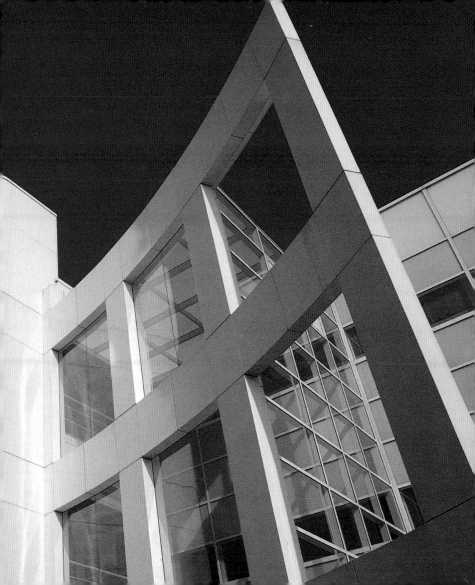

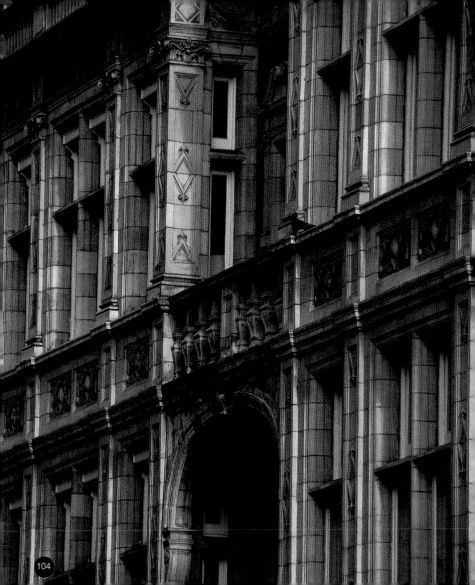

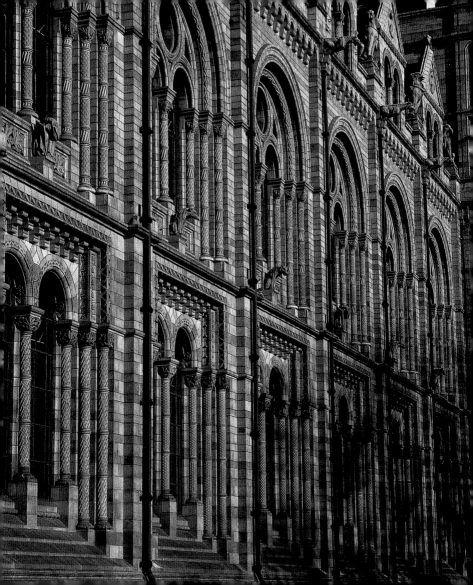

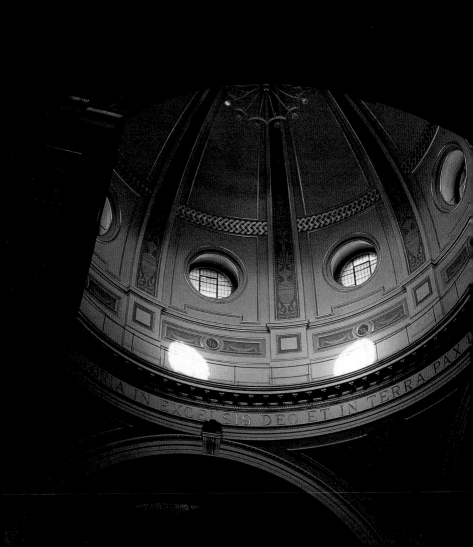

Circular windows from St Clement Danes on the Strand, built by Sir Christopher Wren in 1680 (top), and Essex Street Market Church (above).

Left The Brompton Oratory in Knightsbridge, the foremost Roman Catholic church in London. Officially called the 'Church of the London Oratory' it is part of the Order of the Oratorians, a world congregation of priests founded in 1575 by a Florentine priest and established in Britian in the 19th century. Designed by architect Herbert Gribble in 1884 and based on the Chiesa Nuova in Rome, its dome was added ten years later.

Reliefs and friezes

The greatest frieze of all was installed in the British Museum in 1816. This continuous procession of worshippers of c.440 BC, removed from the Parthenon by Lord Elgin, inevitably inspired followers. The Royal Albert Hall has its own outstanding example. Completed in 1871, the oval concert hall has a frieze depicting the 'Triumph of Arts and Letters', executed in terracotta mosaic. A frieze enables a sophisticated group of subjects to be combined in one ensemble: goldsmiths and cathedral builders jostle one another. Sir William Hamo Thornycroft sculpted their successors in the 1890s on the Institute of Chartered Accountants in the City.

The 20th century departed from the classical example: while cinemas carry reliefs of glamorous throngs, Sargeant Jagger's gaunt Royal Artillery war memorial at Hyde Park Corner depicts in brutal sharpness the destruction of trench warfare. Reliefs often explain the activities and ideals of a building's occupants. Eric Gill's exquisite reliefs on Broadcasting House of the 1930s depict Ariel, in reference to the BBC's mission of communication. Heal's has a series of reliefs emblematic of its furnishing products. The Royal Institute of British Architects' building in Portland Place (1932-4), covered in Art Deco symbolism, shows how great a contribution relief sculpture can make to a building.

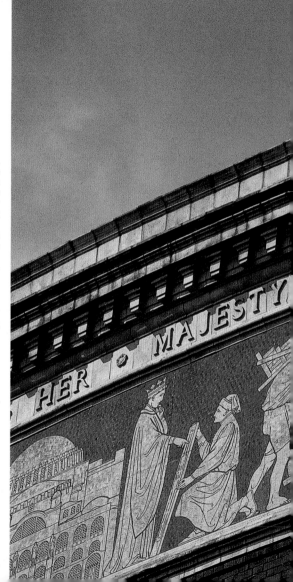

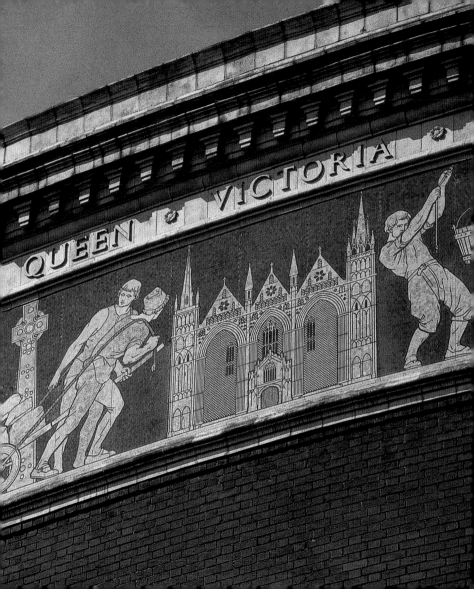

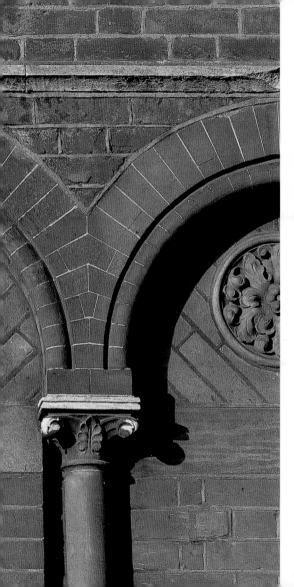

Previous Pages
108/109 A high-relief
sculpture of 1931
created by Eric Gill
for Broadcasting
House in Portland
Place, Marylebone
(above). The frieze
on the Royal Albert
Hall depicts the
'Triumph of Arts and
Letters' and was
designed by
Armitage, Pickersgill,
Marks and Poynter
(right).

A Romanesque
blind arcade with
foliate capitals from
a church in Highgate
(left), and the shop-
front of wine
merchants Berry
Brothers and Rudd Ltd
of St James's **(above)**.
Built in the early
1730s, this is one of
the few surviving
18th-century shop-
fronts in London.

Following pages
112/113 Ornate
entrances in the City
(112 top and bottom),
Whitehall **(113 top)**
and Kentish Town
(113 bottom).
114/115 A Coade
stone ornament in the
classical style
in Bedford Square,
Bloomsbury.
Thoughtto have been
designed and built by
Thomas Leverton, this
is the only complete
18th-century square
in London.

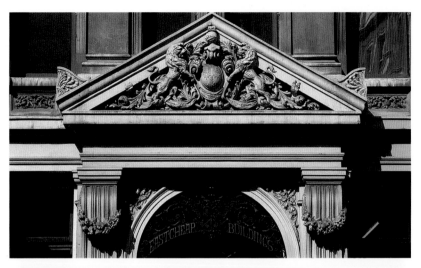

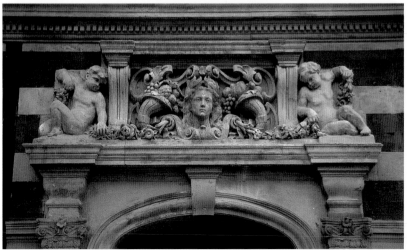

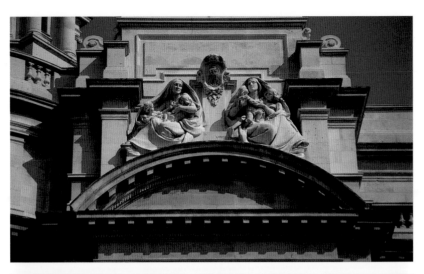

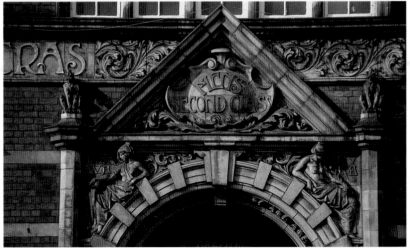

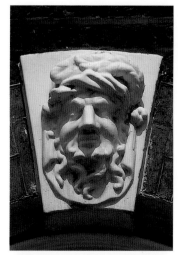
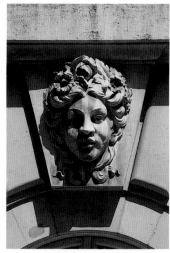

Coade stone keystones from Bedford Square in Bloomsbury **(top and bottom left)** and Curzon Street in Mayfair **(top and bottom right)**; and decorative window details from Queen Anne's Gate **(opposite left and right columns)** and Maida Vale **(opposite centre column)**.

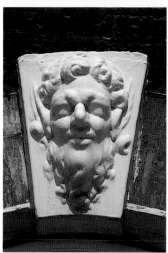
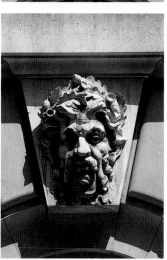

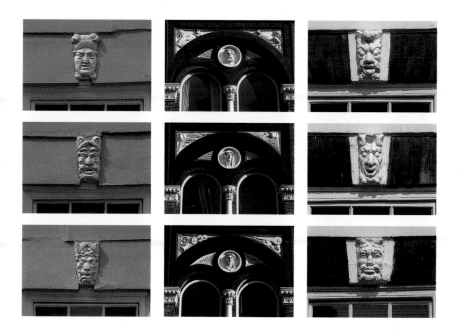

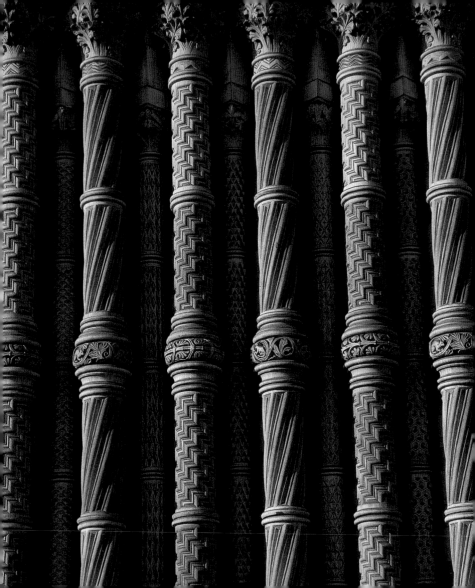

Terracotta

The heyday of terracotta in London was between 1880 and 1900. Before then, designers and manufacturers had been gradually waking up to the potentials of the material, after centuries of neglect. Coade stone, so popular in the Regency period, is almost a terracotta, and showed what might be done for London's architecture with durable, moulded features. The mid-Victorians took the idea further, producing arches and ornaments in terracotta from about 1860. The outstanding monuments from this phase are the courtyard at the Victoria & Albert Museum and Dulwich College.

But it was Alfred Waterhouse who turned an experiment into a fashion by lavishing terracotta upon every visible surface of his Natural History Museum, inside and out. This *tour de force* proved that anything could be made out of the material: multicoloured walls, standardized architectural ornament, or the finest figurative sculpture. For twenty years, terracotta took the London building world by storm. It found the greatest favour on the brasher, self-advertising types of building such as shops, theatres, pubs and the larger City offices, above all, the Prudential in High Holborn (by Waterhouse again). On houses, churches and schools it tended to be confined to dressings. One good argument for terracotta's use was that its highly-fired, colourful surfaces stood up to London's filthy atmosphere and were easy to clean.

The bombastic Harrods facade displays the complexity of the art of terracotta-building. Its components were supplied from the South Bank by Doultons of Lambeth, but there was fierce competition from northern manufacturers. After about 1905, there came a shift in fashion to faience, subtly different from terracotta. Faience can be shiny, robust and aggressive, as on the early blood-red tube stations of the Piccadilly and Northern Lines, or delicate, recessive and almost stone-like, as on the better inter-war shops and cinemas. In the end, it became so reticent that it fell into disuse as a cladding material.

Clusters of ornamental columns in terracotta from the Natural History Museum, South Kensington.

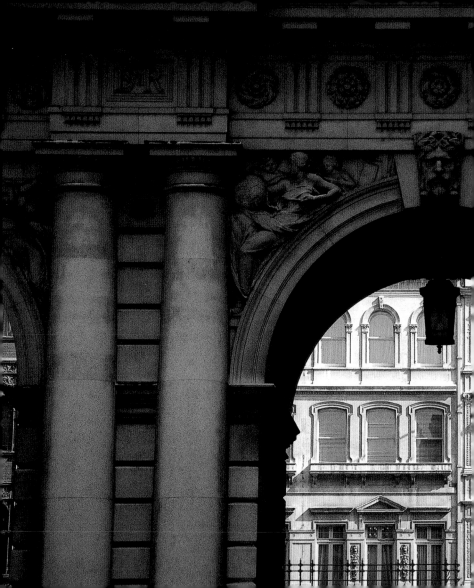

Whitehall in
Westminster. The
name of this street
may derive from the
whiteness of the
stone used in King
Henry VIII's Palace
of Whitehall erected
in the 1520s, which
was situated
at the north end of
the street.

Following pages
122/123 Offices in
the City **(122)** and
Waterloo **(123)**.

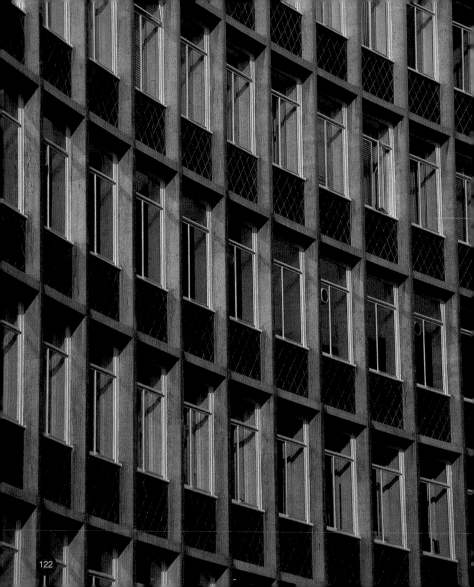

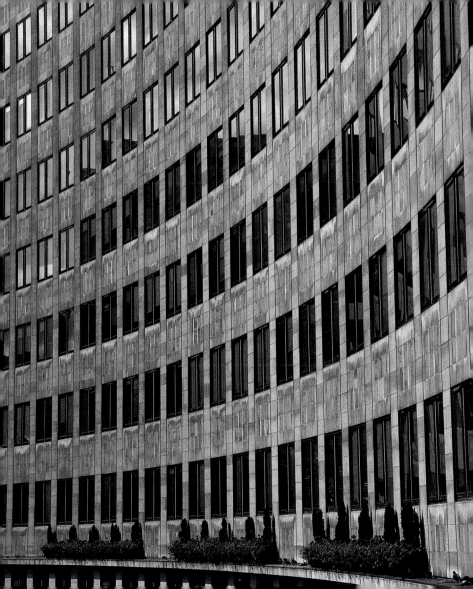

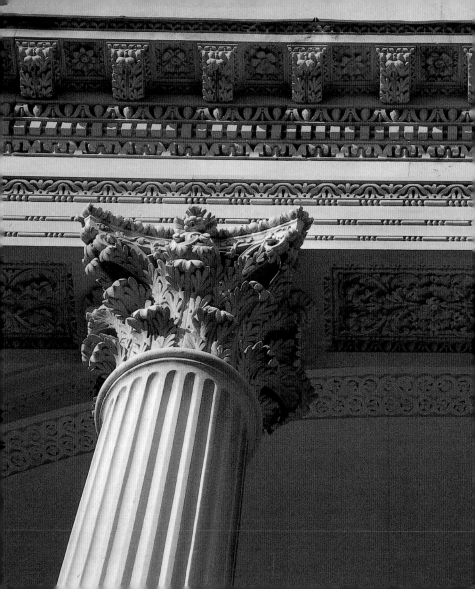

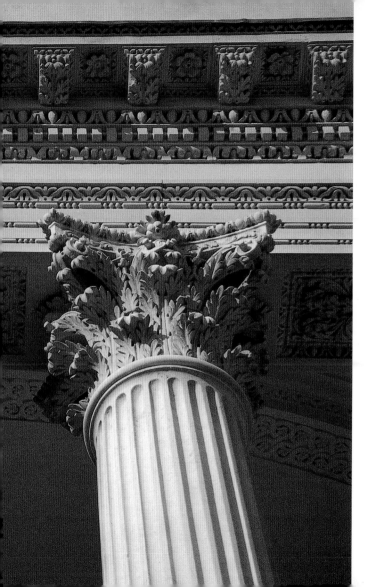

The giant columns
of Chiswick House
modelled on
Palladio's Villa
Rotonda in Vicenza
and built by the
architect Lord
Burlington in 1729.

**Following pages
126/127** London's
most famous high-
tech building, the
Lloyd's building in
the City, was
designed by the
Richard Rogers
Partnership for
Lloyd's of London,
and was completed
in 1986.

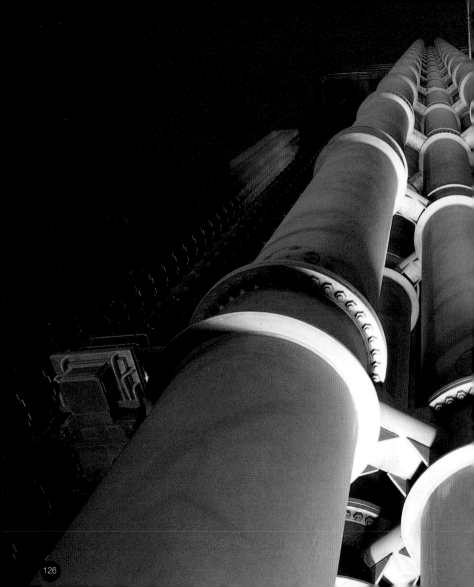

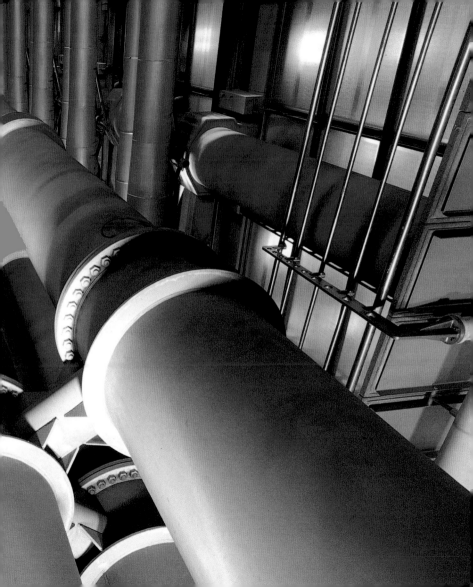

Spires and towers

Many medieval churches of London were small with no towers, but most had something conspicuous about them. After the Great Fire reduced many to rubble, Wren and his team produced incomparable variations on a theme. Church towers had a function in defining the parish and they told their own hour in an age when time was far from standardized. Vestries and churchwardens tried to outdo each other's towers; their authority and identity were at stake.

The tower-building urge is a Gothic one at heart. Both Hawksmoor's and Wren's finer steeples spring from that tradition; it was Hawksmoor who raised the twin towers of Westminster Abbey. At St Martin's-in-the-Fields, Gibbs countered this elaboration with a neat pairing of classical portico and spire which was mimicked round the world. The solution became standard in London for decades, till two church towers of the 1810s, St Pancras by the Inwoods and St John-at-Hackney by Spiller, reawakened the tower-building tradition. Then came a glut of Victorian ecclesiastical invention: All Saints', Margaret Street, St Augustine's, Kilburn and the exotic pencil of Westminster Cathedral are the undoubted masterpieces.

London also had its share of vigorous industrial towers, like the lamented Shot Tower from the South Bank site. It also sported institutional towers on schools, hospitals and public buildings, dressed-up to hide water tanks for emergency use, as at the Natural History Museum. And it has its tower blocks, now selectively worming their way into people's affections. Trellick Tower, north of the Westway, is the architects' favourite, its liftshaft semi-detached from the slab of maisonettes in a show of concrete bravado.

The dramatic obelisk-like spire of the church of St Martin's-in-the-Fields, Trafalgar Square, designed by James Gibbs in 1726 **(above)**, and the clock tower of Dulwich College New Buildings, rebuilt by Charles Barry Junior in 1866 **(opposite)**.

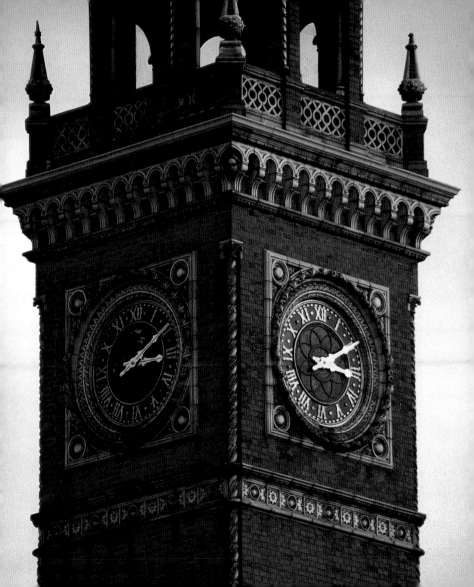

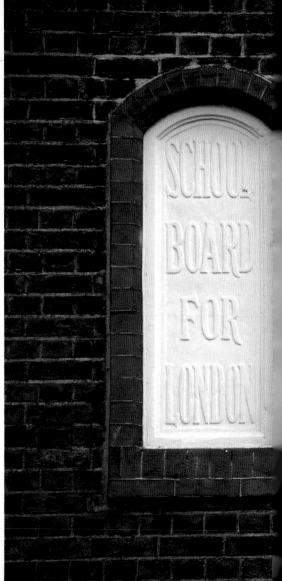

Above The Giraffe House of London Zoo in Regent's Park. The zoo was laid out by Decimus Burton from 1827, and this is one of his two surviving buildings.

Right Plaques from the London School Board, Southwark.

Following pages 132/133 Facade from King's Road, Chelsea **(132 top)**, Monmouth Street, Covent Garden **(132 bottom)**, St John's Wood **(133 top)** and Hampstead **(133 bottom)** displaying different forms of ornamentation.

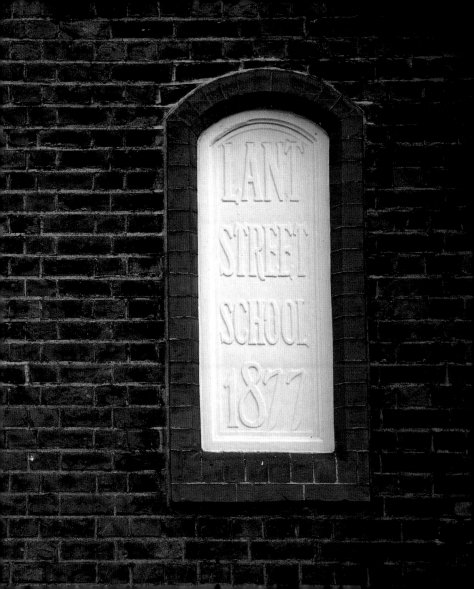

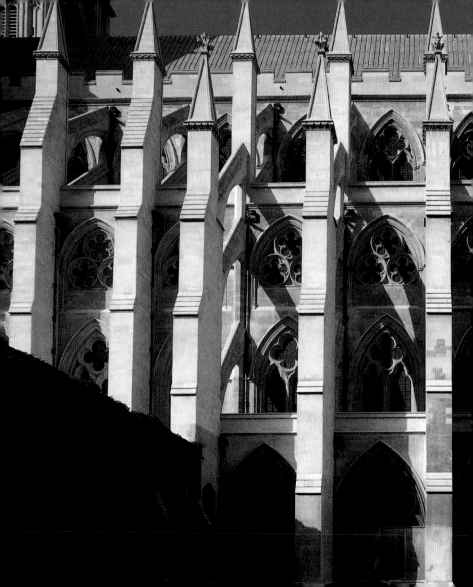

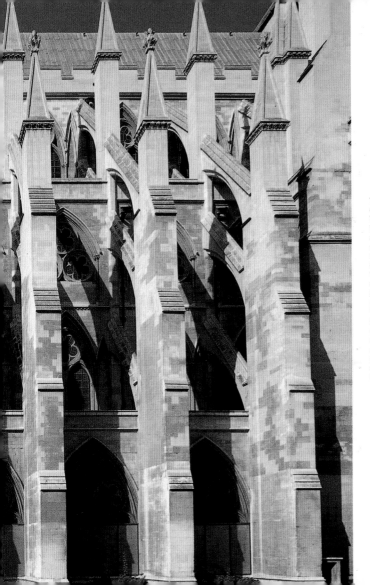

The majestic Gothic cathedral of Westminster built between the 13th and 15th centuries with later additions in the 18th century. Commonly called Westminster Abbey, its official title is the Collegiate Church of St Peter in Westminster; it has been the site of the coronation of English monarchs since William I. Pevsner called it 'the most French of all Gothic Churches'.

A pair of friezes from the Institute of Directors on Pall Mall **(top)**, and Cumberland Terrace, Regent's Park, designed by John Nash **(bottom)**; and a detail from Robert Adam's Kenwood House, Highgate **(far right)**.

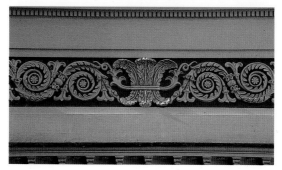

Ceramics

The architectural use of glazed ceramic tiles was pioneered in ancient Mesopotamia before 900 BC. In Roman and medieval London, glazed and patterned floor tiles were a luxury item; none remain intact, but the best surviving example is the 13th-century Chapter House of Westminster Abbey. After this, the architectural use of ceramics languished until the 19th century, when Victorian inventiveness combined with a love of bright colour to produce a variety of tilework: garden paths, porches and fireplaces were brightened by their efforts. At All Saints', Margaret Street, William Butterfield used geometrical tiling for its strong polychromatic effect. On a yet grander scale, the Victoria & Albert Museum commissioned a gallery, tea room and staircase lined with superb moulded ceramic work.

In 1877 the artist Frederick Leighton built the delightful Arab Hall in his house and lined it with his collection of 13th- and 17th-century Middle-Eastern tiles; more beautiful tilework by William de Morgan lines the staircase. The architectural ceramics' heyday dated from 1880 to 1914, as the great china companies started huge-scale production of cladding. The Doulton factory produced the brilliant blue-green and white surface of Sir Ernest Debenham's 1905 Kensington house. A rival company, Burmantofts, produced the art nouveau-style cladding of the Michelin Building, Fulham Road. Their cream-coloured 'Marmo' tiles were adopted by the Lyons Corner House group and cover the Regents Palace Hotel of 1913-14, and the later Strand Palace Hotel.

Tiled facades remained popular in the inter-war period, as on the multicoloured Egyptian-style facade of the Carlton Cinema, Essex Road, Islington. Although architectural use of ceramics has been neglected of late, one initiative keeps the idea alive. The famous Blue Plaque scheme erects ceramic plaques of a Luca della Robbia blue to mark former residences of the great and good.

Maida Vale Underground Station. Leslie W Green was the architect of many of the characteristic London Underground stations, creating ninety-five stations in five years from 1903 to 1908 when he died prematurely. Although their details vary, they are all built using a steel frame clad in crimson glazed terracotta blocks.

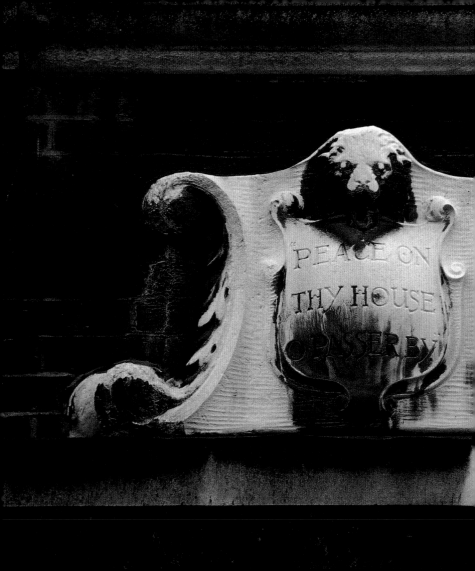

Ornamental animal heads from Westminster **(left)** and the City **(top)**, including a detail from the bronze door of the Bank of England **(above)**.

Following pages 142/143
A panoramic view of Hampton Court Palace, Hampton Court, erected by Cardinal Wolsey in 1515. In 1604 it was the site of the conference authorizing the King James Bible. **144/145** Details from John Nash's All Souls, Langham Place, Upper Regent Street, completed in 1824.

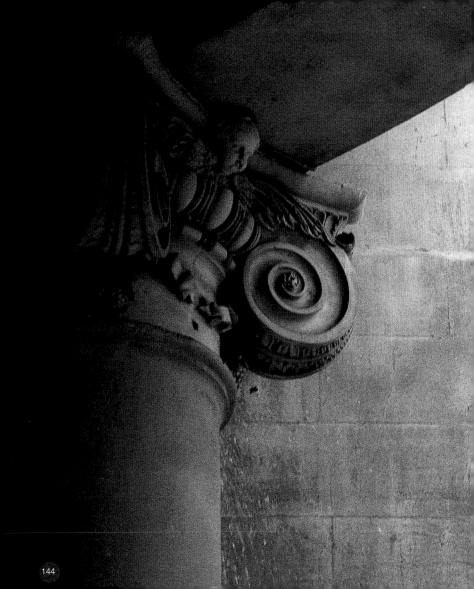

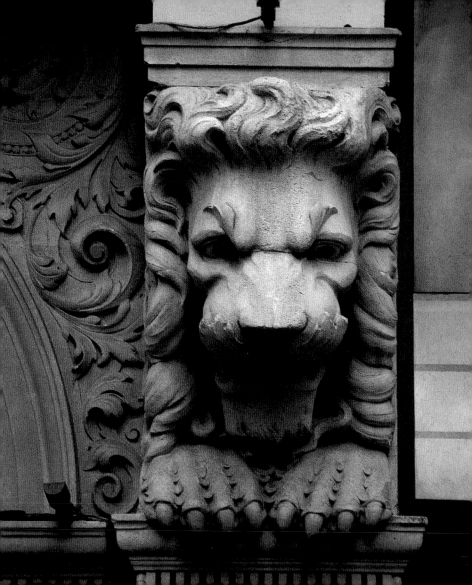

A pride of lions from
the City **(opposite)**,
Maida Vale **(top left)**,
the British Museum,
Bloomsbury
(bottom left),
the Science Museum,
South Kensington
(top right), and
appropriately London
Zoo, Regent's Park
(bottom right).

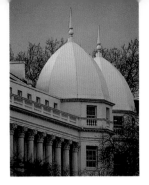

Domes

The first domed building in England is still its greatest. Christopher Wren's inspiration for the dome of St Paul's Cathedral, completed in 1711, was Bramante's Tempietto built in Rome two hundred years earlier. Indeed, many London domes owe their origin to the Tempietto, even if they have reached us by way of other buildings in Rome, Venice and Paris. Of course, there were domed buildings before Bramante, notably Brunelleschi's in Florence, to which John Nash pays a whimsical tribute with his pairs of ribbed miniatures in Sussex Place, Regent's Park. There are also a few oriental domes that owe little to western influence but lean rather on Cairo and Constantinople.

The mightiest dome in antiquity is the Pantheon in Rome, completed in the second century of the Christian era. Two famous London Victorian buildings borrow its shape and have its upturned, saucer-like roof: the Royal Albert Hall and the British Library's Reading Room in the British Museum. Devised by the librarian, Anthony Panizzi, and designed by Sidney Smirk, it has a dome of glass and iron 141 feet in diameter, only two feet less than the Pantheon itself.

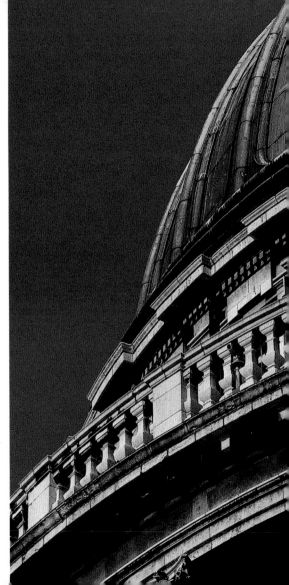

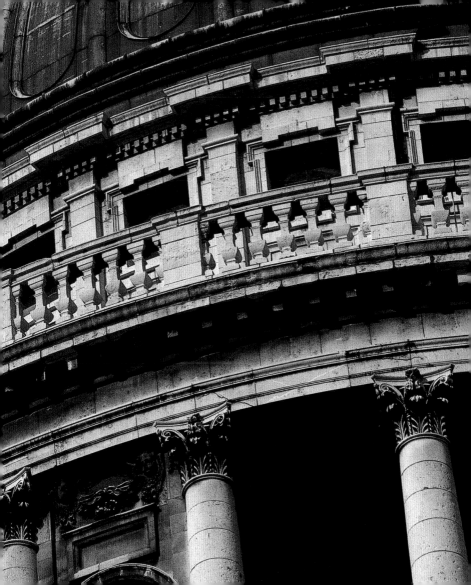

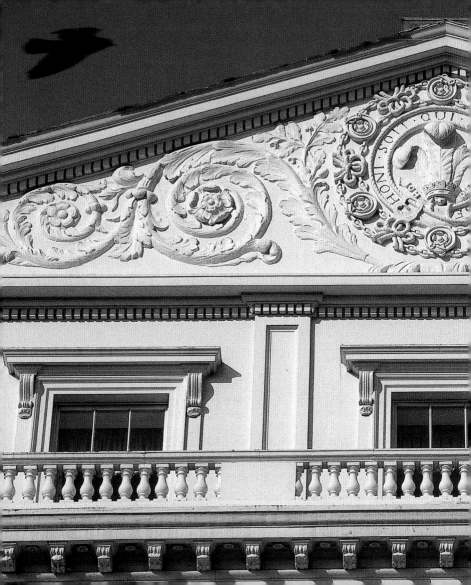

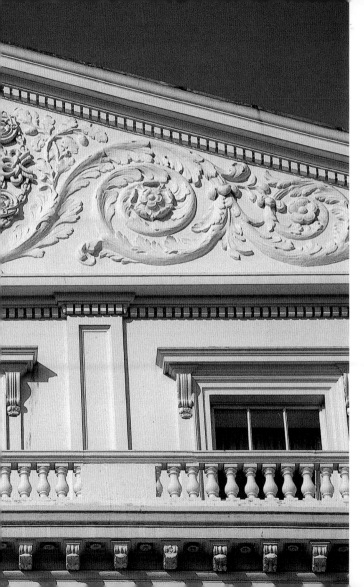

**Previous pages
148/149** The dramatic obelisk-like spire of the church of St Martin's-in-the-Fields, Trafalgar Square, designed by James Gibbs in 1726 **(above)**, and the clock tower of Dulwich College New Buildings, rebuilt by Charles Barry Junior in 1866 **(right)**.

Carlton House Terrace on the Mall, completed in 1832, was John Nash's last design. The Prince of Wales feathers and garter in the central pediment commemorate Carlton House, the residence of the Prince Regent, the site on which Carlton House Terrace was built.

**Following pages
152/153** The tulip staircase in the Queen's House, Greenwich, based on that in Palladio's Villa Rotonda in Vicenza, and so called because of the repeating pattern of the balustrade.

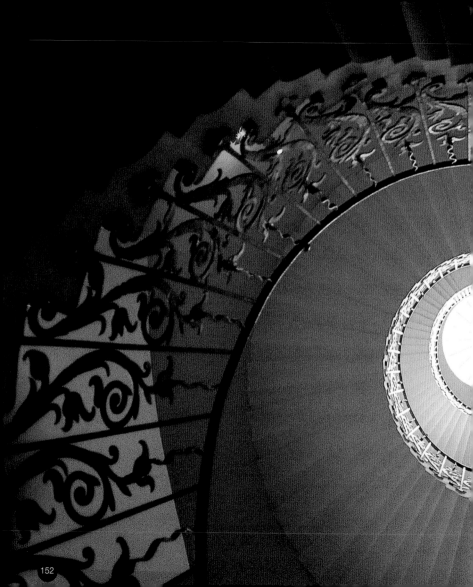

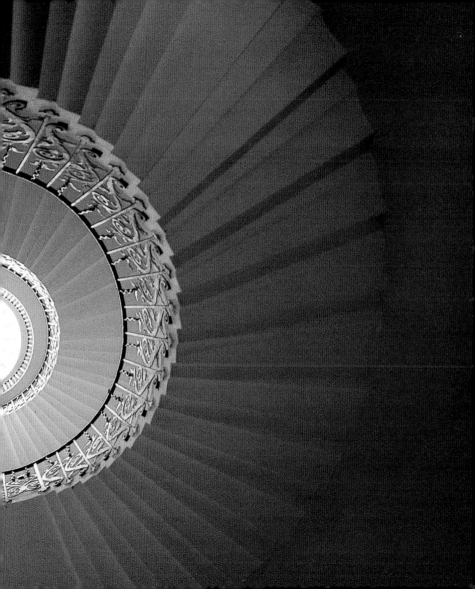

Osterley House in Isleworth, designed by Robert Adam and completed in 1767.

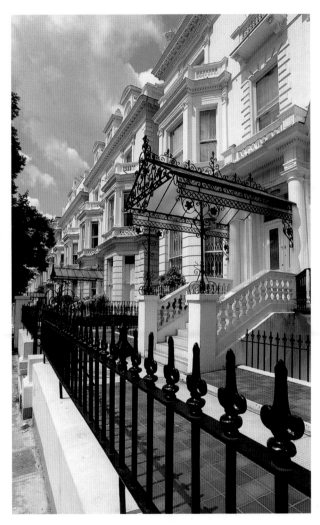

Holland Park Gardens in Holland Park is built on an area which formed part of the estate of the Earls of Holland which was sold by them in 1866.

Following pages
156 Paddington industry nestling beneath a Dutch gable. Charles Rickards Ltd was a chain of garages operating during the 1920s and 1930s. This lettered gable marks their conduit garage behind Praed Street, Paddington. **157** The clock tower above the front entrance of the Royal College of Music, South Kensington, designed by Sir Arthur Blomfield and completed in 1894.

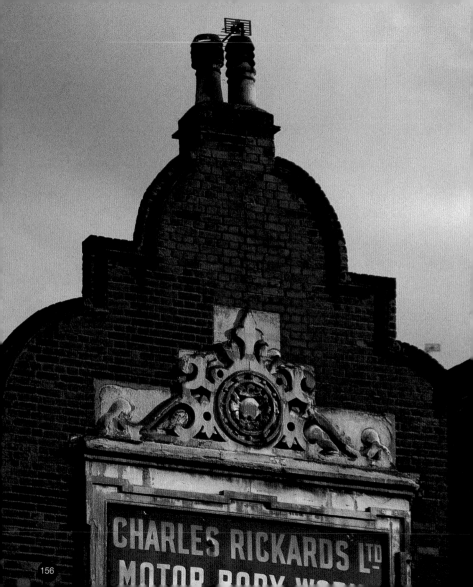

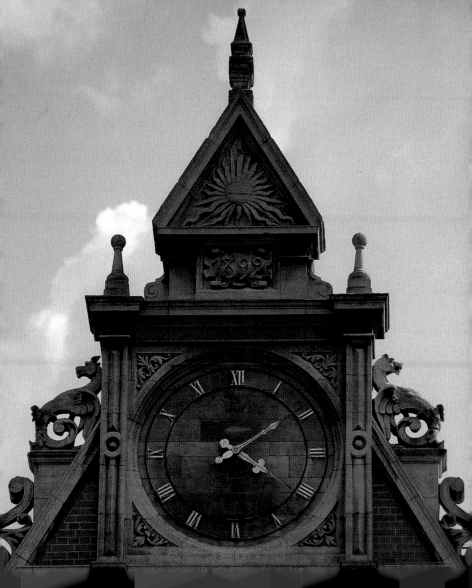

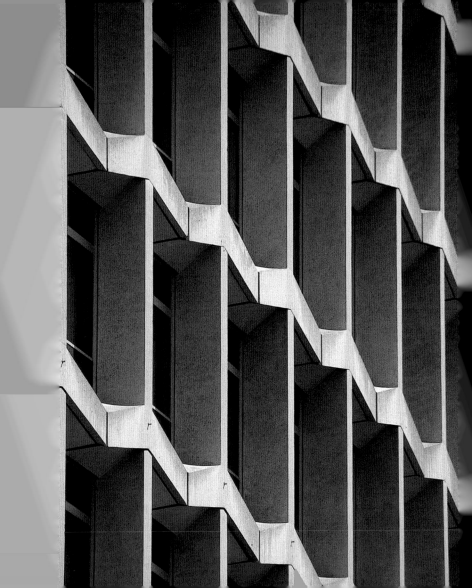

Concrete

Concrete is the most misunderstood of all building materials, though it has a long and honourable history. The Romans were masters of its use, most famously for the dome of the Pantheon. Concrete is aggregate, sand and binder. The Romans had a natural binder, Pozzolana, which also set under water, creating a concrete suitable for many uses. In later centuries, lime was the traditional binder but was less reliable. Only in the mid-18th century, when Smeaton discovered why only certain limes set in water, was concrete used again with confidence. Robert Smirke made the first large-scale use of concrete for the foundations of his Millbank Penitentiary in 1817, while Barry built the Houses of Parliament on a concrete raft in the 1840s.

However, the development of concrete for modern structural and architectural purposes began with the invention of Portland cement, a strong artificial binder with Pozzolana's properties. Its potential was appreciated after its use on Bazalgette's Drainage Works during the 1860s, encouraging its wider use towards the end of the century.

Concrete in architecture as we know it today came about with the introduction of concrete reinforced with steel rods, giving it tensile strength and extending its uses. Because reinforced concrete is made in moulds it is adaptable to many shapes, a quality of which the 1930s architects took full advantage, notably Lubetkin's Highpoint flats and his Penguin Pool at London Zoo where the intertwining ramps showcase its structural virtuosity. The post-war period saw an explosion in its use both for high-rise housing estates, tunnels and underpasses.

Unfortunately, concrete does not wear well and almost all concrete buildings have suffered in the damp British climate. Nevertheless, there are some successful modern examples such as Lasdun's National Theatre, which make effective use of exposed concrete, while Casson's Elephant House at London Zoo with its ribbed form and hammer-exposed aggregate finish elegantly expresses the nature of the material.

Centre Point, New Oxford Street, was built by Richard Seifert and Partners and completed in 1967. Known colloquially as the 'honey-comb building', it is thirty-five storeys high and is made from prefabricated, precast concrete elements: a conspicuous monument to its own limitations.

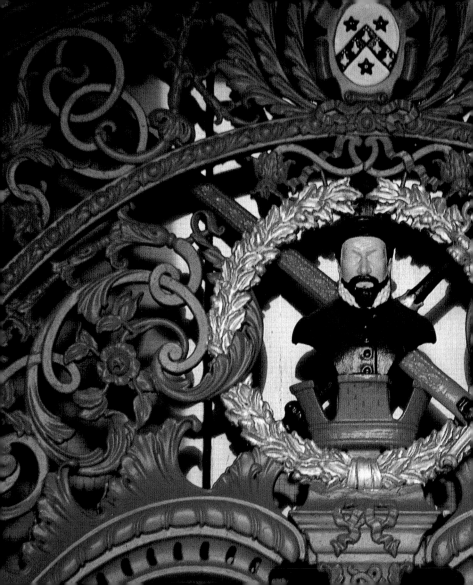

Devices on City
buildings including
a decorative
ironwork detail from
the Royal Exchange
commemorating
its founder,
Sir Thomas Gresham,
who seems to be
turning a blind eye
to what goes on
inside **(left)**.

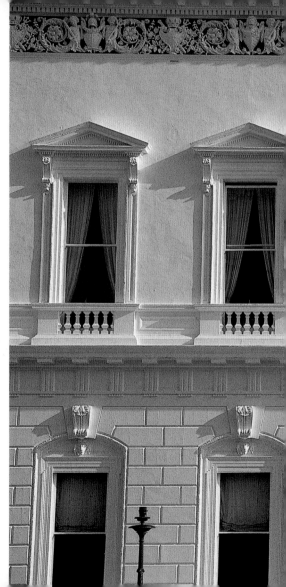

Above A detail of iron railings from Temple in the City.

Right The facade of the Institute of Directors. Formerly the United Services Club on Pall Mall, it was built by John Nash in 1828, and later remodelled by Decimus Burton to resemble more closely his Athanaeum opposite in Waterloo Place. This view of the Waterloo Place facade shows the gas torches which are lit on state visits, Waterloo Day, Trafalgar Day and Battle of Britain Day.

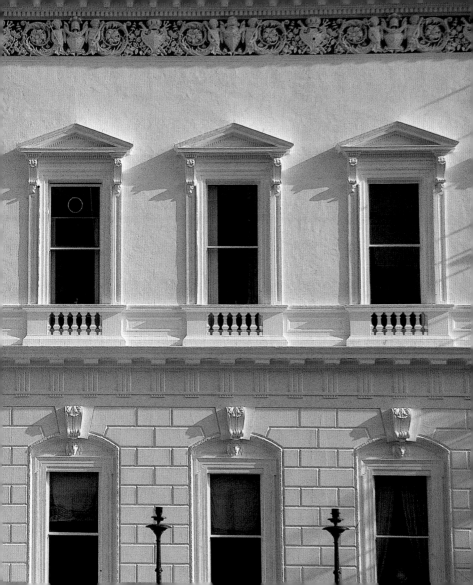

OTED FRIEND OF

Left A bench in Highgate, with a donor's inscription.

Top A courtyard door at Burlington House, Piccadilly, home of the Royal Academy.

Above The frosted glass window of a public house in the King's Road, Chelsea.

Following pages
166 The Oxo Tower in Southwark, by architect A W Moore. The decorative glazed lights in the tower spell out the word 'Oxo'.
167 The copper-clad Art Deco clockface of the Gillette Factory in Middlesex, by Sir Banister Fletcher.

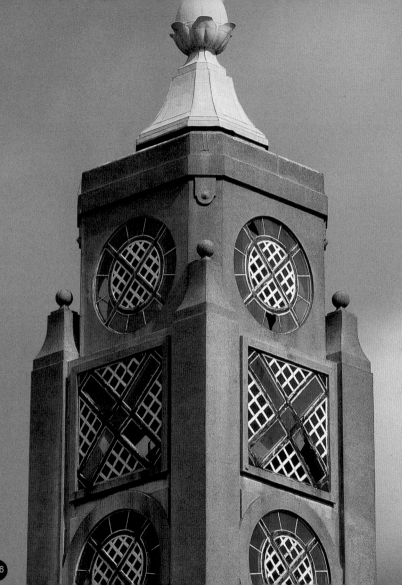

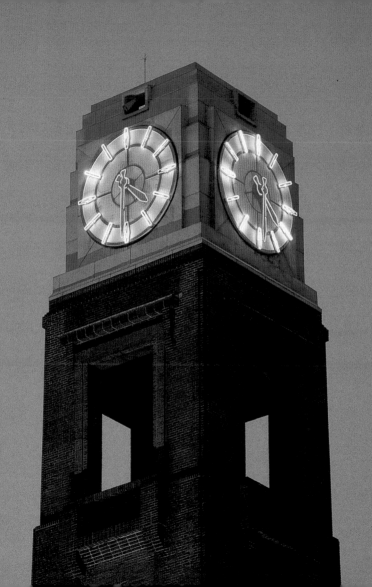

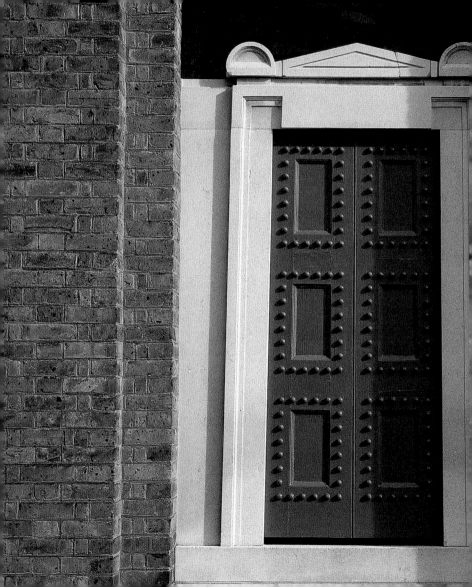

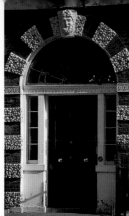

Arches and doors

A front door is a potent symbol – of home, of privacy, of property – and this is especially true of London's terraced house where it is so often the only feature of note. Early 18th-century houses offered shelter to the visitor in the form of a hood over the doorstep, as at Queen Anne's Gate, but soon after Tuscan or Ionic pilasters provided a more orthodox Palladian treatment. The mid-18th century also produced the fanlight which has added enormous visual pleasure to the street scene; notably in Bloomsbury, Mayfair and Soho. The grander town houses sometimes had proper porches, the commonest form of which, two stuccoed Tuscan columns supporting a heavy cornice, was liberally used in the development of Belgravia in c.1820-50, and in South Kensington and Holland Park.

The medieval City, too, had gateways which survive only as streetnames: Bishopsgate, Newgate, Aldgate, and so on. The last of the great gates, Temple Bar, was rebuilt in the 1670s and spanned Fleet Street until its removal to Theobalds Park in the 1870s.

A synagogue on Upper Berkeley Street, Marylebone **(top)** and Temple Church in the City **(above)**.

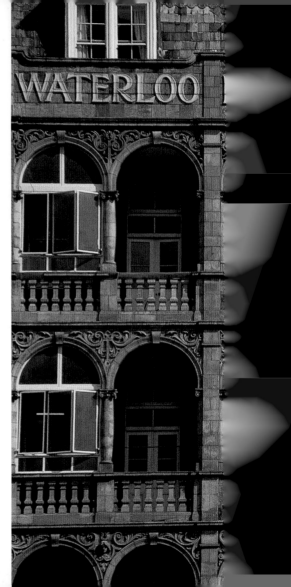

Right The Royal Waterloo Hospital, Waterloo, built in 1905 by M S Nicholson. This impressive facade comprising a three-tier terracotta loggia with lettered glazed tiles is based on the Lombardic Renaissance style.

THE
ROYAL
AL FOR CHILDREN AND WOMEN

SUPPORTED BY
RY CONTRIBUTIONS

PATRONS
ESTY KING EDWARD VII
STY QUEEN ALEXANDRA
NESSES THE PRINCE & PRINCESS OF WALES

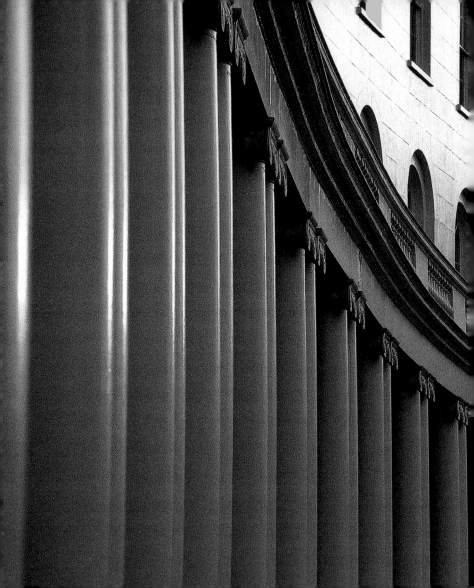

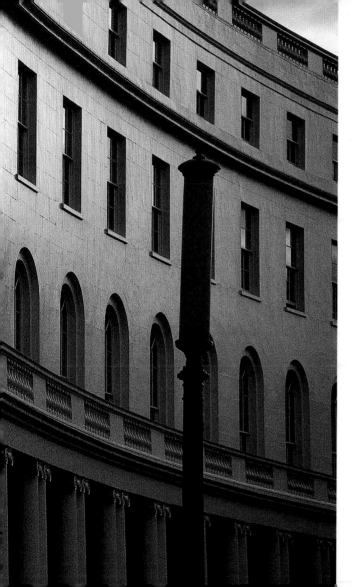

A sweeping view
of John Nash's
Park Crescent
in Regent's Park
showing the
magnificent
colonnade of paired
Ionic columns which
were originally
intended to form
part of a circus.

**Following pages
174/175**
The Lloyd's building
in the City showing
to advantage its
modular
construction.

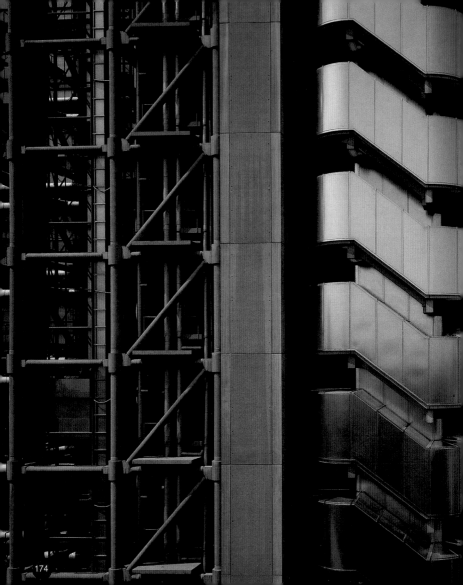

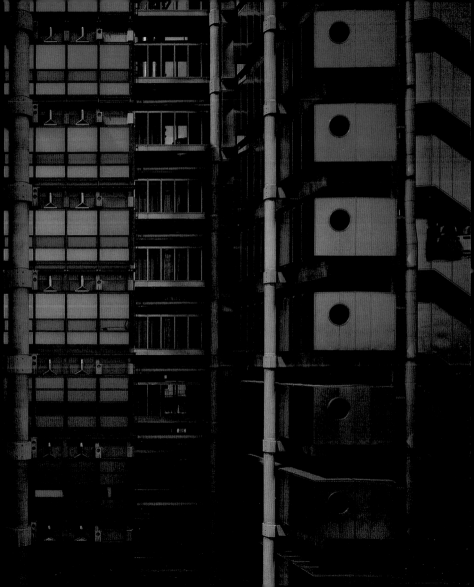

Right Hawksmoor's distinctive spire of Christchurch, Spitalfields; completed in 1729 it is the most dramatic of all his City churches.

Far right A view of St Martin's-in-the-Fields through the entrance colonnade of the National Gallery in Trafalgar Square. Built by William Wilkins, the gallery was completed in 1838; these giant columns once belonged to Carlton House which was demolished in c.1827.

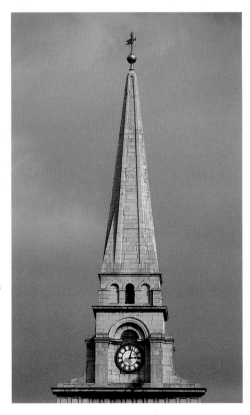

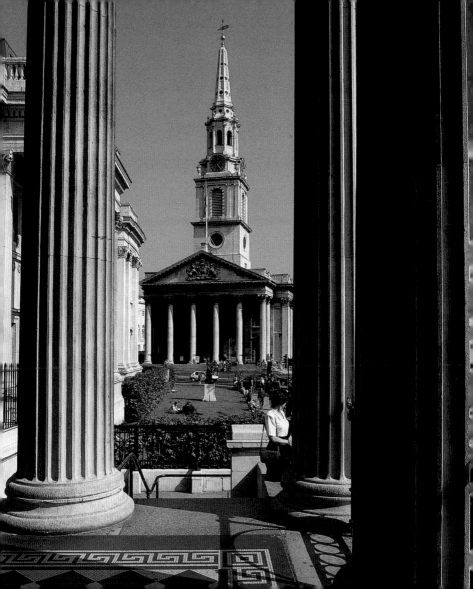

Wood

Wood is the oldest of building materials, except perhaps for mud, and the least durable. It can be eaten by insects, attacked by fungus, consumed by fire and rotted by water. That is why, in modern London, there are no old wooden buildings. Five hundred years ago, almost all London houses were of wood. All building in timber was within the purview of the Carpenters' Company or the Joiners and Sealers. While the carpenters did the major structural work, the joiners were responsible for the subsidiary tasks of doors, door frames and wainscot. The great hammerbeam roof of Westminster Hall, completed in 1401, bears witness to the high standards of skill maintained by both companies.

Britain was once covered with forest. Most of the larger trees closest to towns had been felled by the time of the Normans, and a trade developed importing oak boards from Germany, and pine and fir from Scandinavia and the Baltic. By the 17th century, wood building was extensive, and even after the Great Fire, it prospered for though the houses within the City were rebuilt in brick, they still required wood for the roof structure, floors and fittings.

Some old wooden houses survived in London till the end of the 19th century, and many of the great industrial buildings, breweries and warehouses, lasted until the last war, but the years which saw the last of these also witnessed their rebirth. The late 18th century saw a renewed enthusiasm for Shakespeare and Tudor architecture. Soon, architects like Norman Shaw were using 'half-timbering' for their great Victorian mansions such as Grims Dyke in Harrow Weald. Prosperous Edwardian and post-Edwardian residential areas were built entirely in this style. It culminated in the purchase by Mr Liberty of the hulks of old wooden battleships for his fashionable store on Regents Street, and eventually permeated the outer stretches of Metroland, covering many miles with identical, mock-tudor dwellings.

One of several distinctive elaborately carved wooden porches from Queen Anne's Gate, Westminster.

A picturesque house in Dulwich with a clapboarded facade, unusual for London though many survive in Kent.

Following pages
182/183 Plaques and roundels including a fire insurance plaque in Camden Town **(182 top)**, two terracotta roundels on the Victoria & Albert Museum **(182 bottom, 183 top)**, and a copper plaque commemorating the Great Exhibition of 1851 on a statue of Prince Albert on the steps of the Royal Albert Hall which was partly built with the proceeds **(183 bottom)**.

BELL COTTAGE

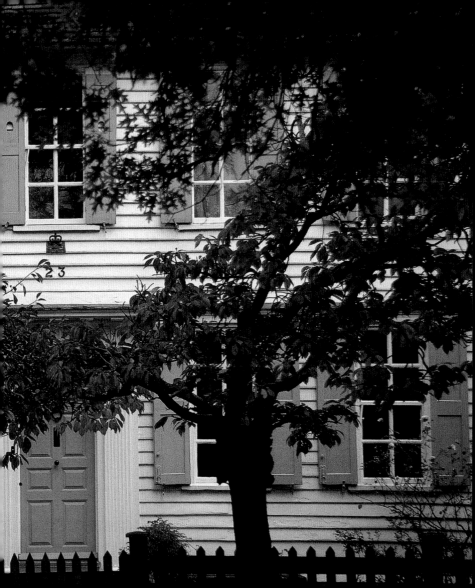

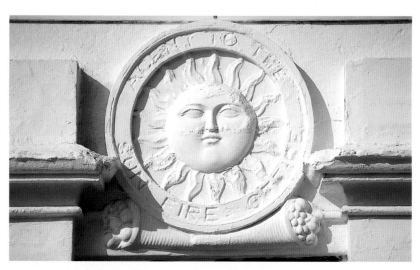

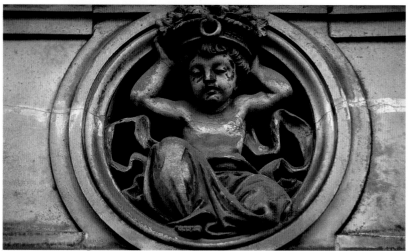

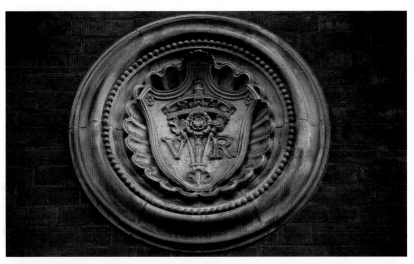

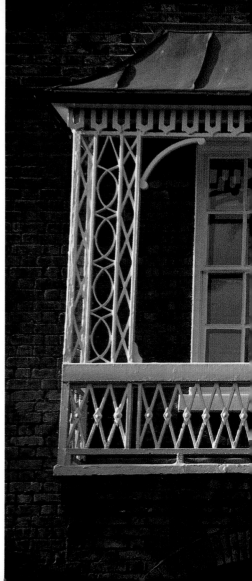

Windows in Holland Park **(top)** and near Harley Street **(above)** decorated with classical swags, and a window in Highgate West Hill with graceful Regency ironwork **(right)**.

Following pages
186 A building on Kingsway cloaked in the trappings of the construction industry.
187 Delicate Art Deco ironwork on the Dorchester Hotel, Park Lane, built in 1930 by W Curtis Green; then as now one of London's most fashionable hotels.

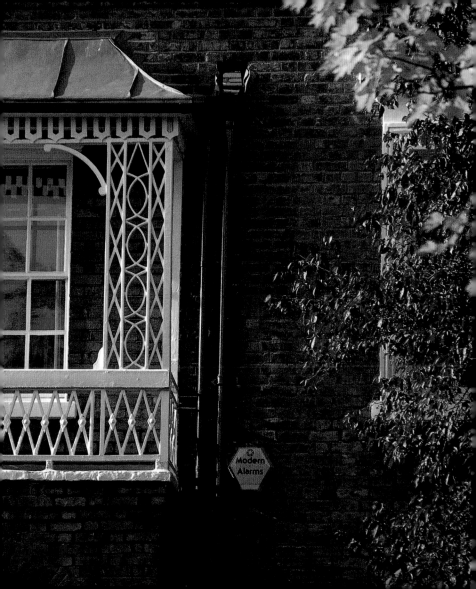

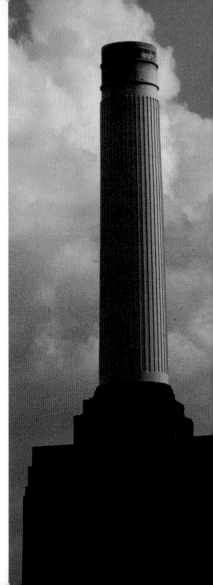

An ebullient group of decorative Tudor brick chimneys from Hampton Court Palace **(right)** and the four chimneys of Battersea Power Station designed by architects Halliday and Agate with Sir Giles Gilbert Scott and built from 1929 onwards. A dramatic landmark on London's skyline it is now alas only a shell **(far right)**.

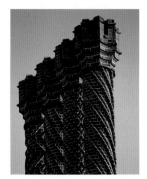

Chimneys

It is not clear when London rid itself of the smoky and dangerous open hearth, but a date related to the large-scale importation of bricks in the 14th century seems likely. London burned coal, brought first from Tyneside and later from Wales. Thus, along with the famous smogs, were born the dramatic cityscapes of brick and occasionally stone chimneys. The variegated ranks of chimney-pots that still decorate the skyline were a 19th-century introduction.

Later in the 19th century architects came to recognize the dramatic possibilities of the chimney stack in their compositional repertoire, Philip Webb leading the trend in 1859 with the Red House, Bexleyheath. At Kew, Eden Nesfield adopted a massive central stack as the focus of his quaint lodge of 1866, a precursor of the so-called 'Queen Anne' style, later ubiquitous in London suburbia in the late 1800s. These architects added artistry to historical sources. Elsewhere there was a more simplistic enthusiasm for matters Tudor with the exploitation of the stack as an exhibition of bricklaying bravado.

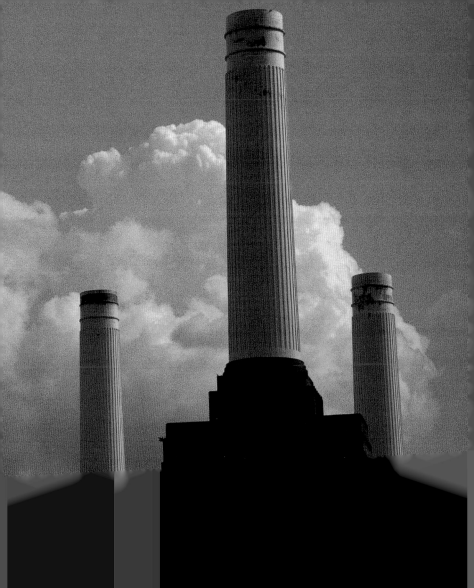

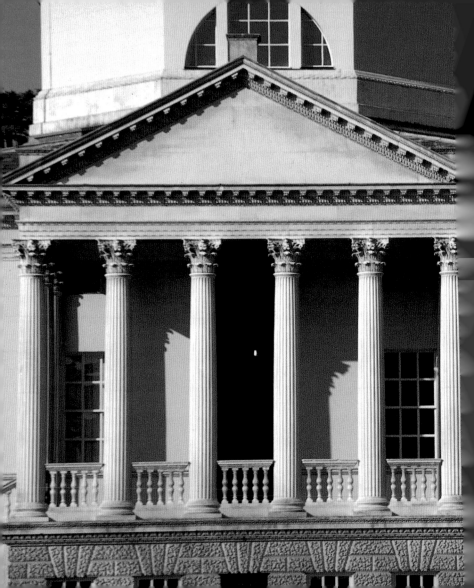

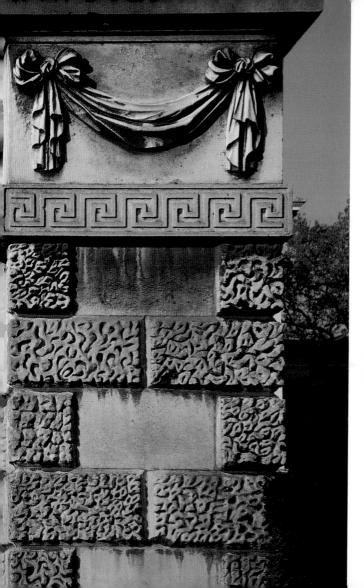

Lord Burlington's Chiswick House completed in 1729. The portico is seen through the gate piers which illustrate the variety and range of Coade stone ornament.

Following pages
192/193 Suspension cables and mast which support the roof of Sainsbury's supermarket in Brentford, designed by Nicholas Grimshaw and Partners.

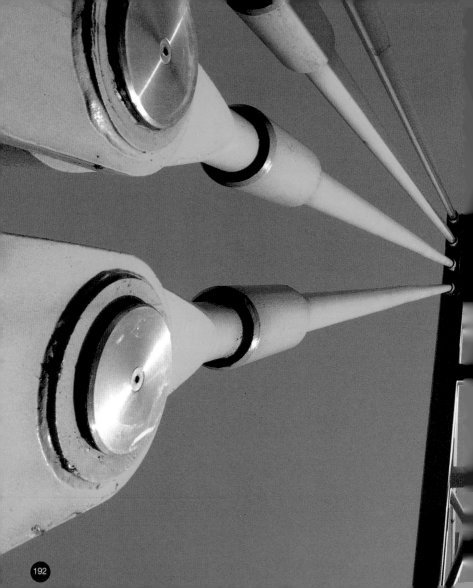

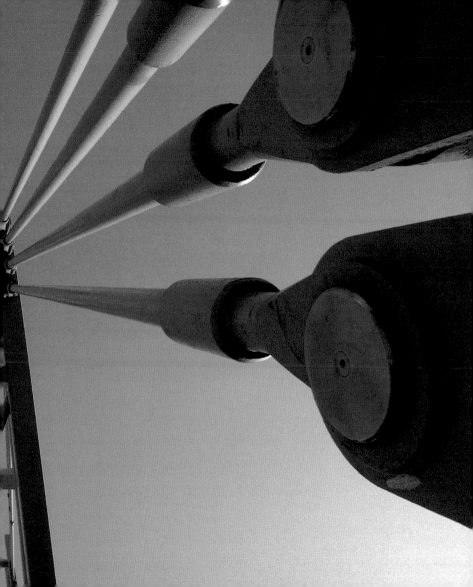

Right Beautifully
proportioned
windows on
a typical London
house, glimpsed
from Whitehall.

Far right
Sir Robert Smirke's
British Museum
in Bloomsbury,
begun in 1842;
modern cares
within an historic
colonnade.

Following pages
196/197 The play of
light on the fluted
columns of John
Nash's Cumberland
Terrace, Regent's
Park **(196)**, and on
the wooden boards
of a doctor's surgery
in Swiss Cottage,
Hampstead **(197)**.

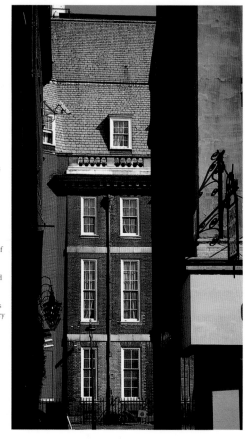

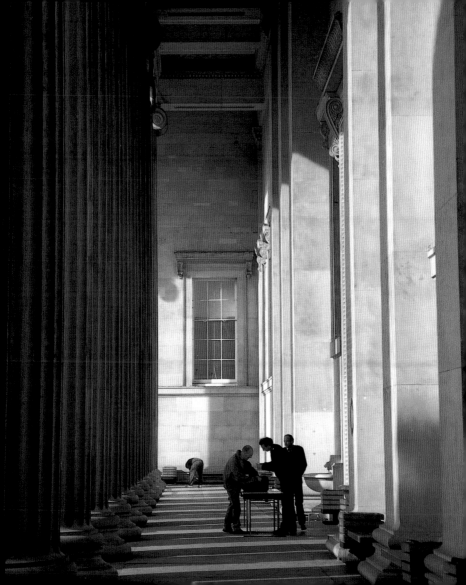

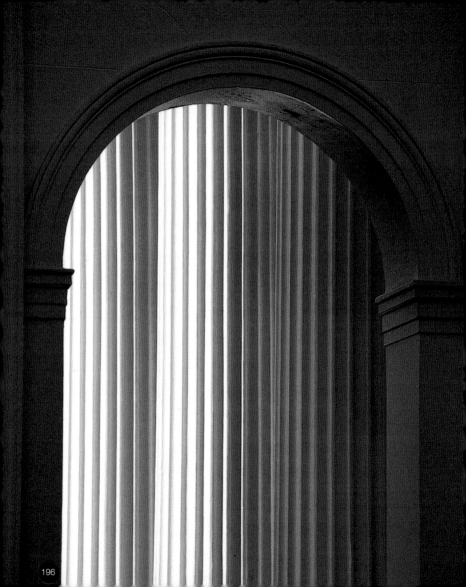

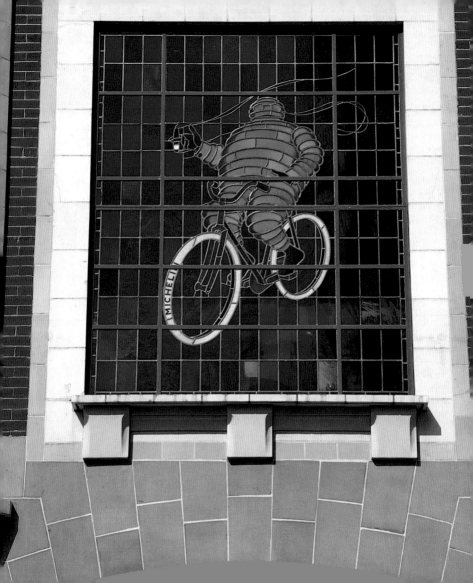

Glass

For medieval stained glass in London we must go to the Victoria & Albert Museum, a collection more internationally prestigious than of local relevance. Otherwise, iconoclasm and bombing have left only fragments, most of them donations to later churches such as All Saints' Margaret Street, designed in the 1850s with 15th-century figures as embellishment. London does better with Georgian glass, as at St Botolph, Aldersgate, where James Pearson's Agony in the Garden of 1788 glows like a dark oil painting.

By contrast the whole history of Victorian glass can be traced in the public buildings and churches of London. From early experiments at Holy Trinity, Cloudesley Square, where in 1829 Thomas Willement produced a medieval east window, through competitions for the Houses of Parliament in 1843, to the great church-building revival of the 1850s, London provided opportunities for glass artists to work with the best architects of the day. The litany of great Victorian churches featuring their work is extensive: St James's the Less, Pimlico by Clayton and Bell, Henry Holiday's St Mary Magdalene, Paddington and All Saints', Putney by William Morris and Burne Jones.

London is also rich in its secular commissions, notably in the livery companies and professional institutions like the Law Society and Royal Institute of British Architects. War memorials like that in the Star and Garter Home, Richmond, saw the continuance of traditional glass in the 20th century, while modern designs have proliferated in hospitals.

But glass design need not be serious or uplifting. Between 1890 and 1914 it was in high favour for advertising products on shop-fronts and for the canopies of theatres. It reached its apogee of technique, vigour and variety in London's pubs, from the acid-etched and embossed screens of the Princess Louise, Holborn, to the art nouveau stained glass of the Salisbury, Green Lanes, in suburban Palmers Green.

The Michelin Building in South Kensington designed by F Espinasse and completed in 1911. Built for the Michelin Tyre Company, its exuberant glass and ceramic decorations advertise the pleasures of motoring.

Following pages 200/201 Designed by architects Campbell Zogolovitch Wilkinson & Gough, the Circle in the Docklands stands on the site of stables established for the Courage Brewery in the early 19th century, which explains the central statue of a dray horse sculpted by Shirley Pace.

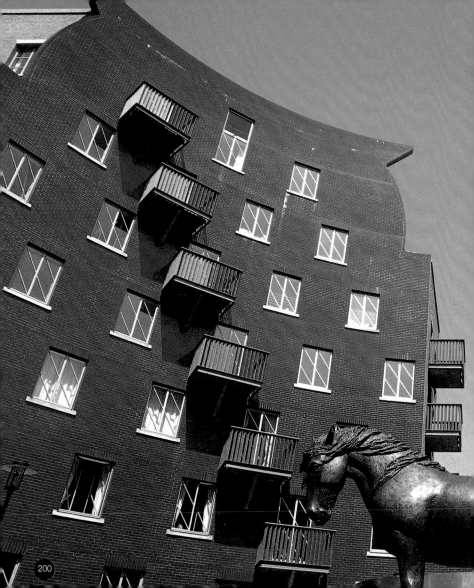

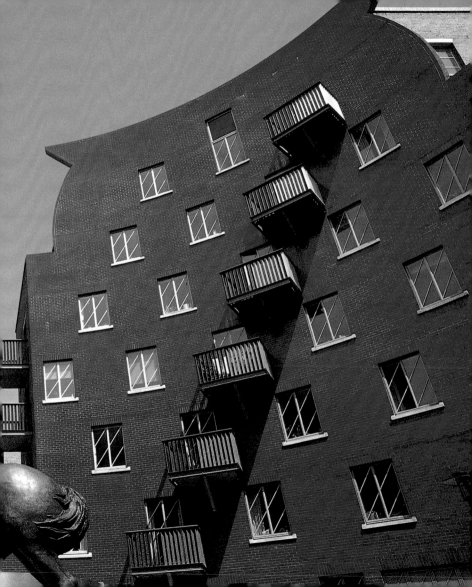

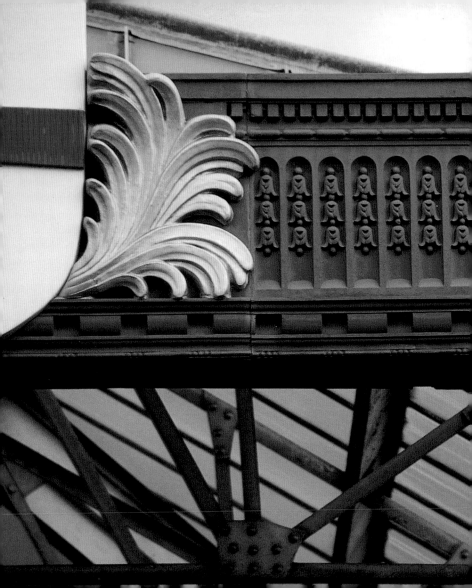

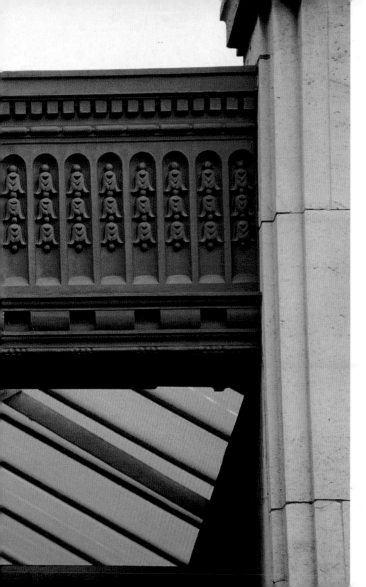

Formerly one of London's main vegetable markets, Spitalfields Market in the City was established in 1682 and designed by the architect George Sherrin in 1881.

Following pages
204 Dazzling reflective glass on buildings in Canary Wharf, Docklands.
205 The copper-clad dome of the Planetarium in Marylebone.

203

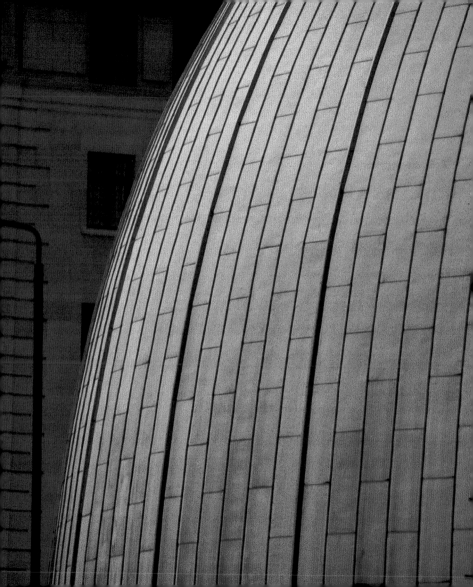

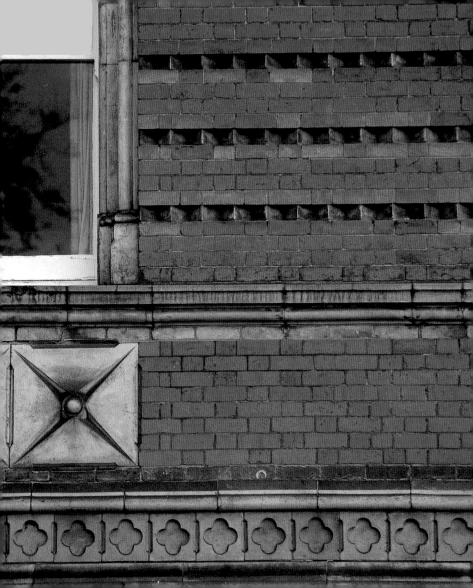

Above Terracotta
reliefs on a house
in Melbury Road,
Kensington **(left)**,
and on a building
in Tottenham Court
Road **(top and
bottom right)**.

Left Dulwich College
New Buildings
designed by Charles
Barry Junior in the
ornate North Italian
Renaissance manner
making extensive
use of brick with
terracotta ornament.

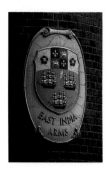

Street signs

There have been street signs in London since Roman times. Originally they were cut in stone, but by the 18th century painted wooden boards were used which hung in front of houses. Since few people could read, signs displayed pictorial representations of what the tradesmen made and sold, or replicas of their wares, such as a pair of spectacles, or a symbol like the striped pole of the barber-surgeon or the three balls of the pawnbrokers; and sometimes the coats of arms of the guild to which the tradesmen belonged.

These signs sometimes crashed down on to the people below. In 1762, Parliament passed an Act forbidding their use in the City of London and Westminster, and ordering all signs to be fixed flat against the facades. Shopkeepers began to paint and gild the fascia of their houses instead and thus decorative shop-fronts developed.

Today, few trade signs are left except for public houses and the occasional pawnbroker. The City Guilds still display their coats of arms, and fashionable establishments which supply the Royal Household proudly fix a royal coat of arms above their doors; but the rest is history.

The coat of arms of the East India Company in the City **(above left)**; a decorative plaque from Heal's store, Tottenham Court Road, devised by Ambrose Heal showing the tools of the furniture trade **(above right)**; and a banking sign on Lombard Street in the City under the gilded patronage of Charles II **(opposite)**.

Following pages
210 Ornamentation on the facade of Boodle's Club, St James's Street.
211 Terracotta ornament in Essex Street near the Strand **(top)**, and vermiculated rustication in Coade stone, a characteristic decorative feature of Chiswick House **(bottom)**.

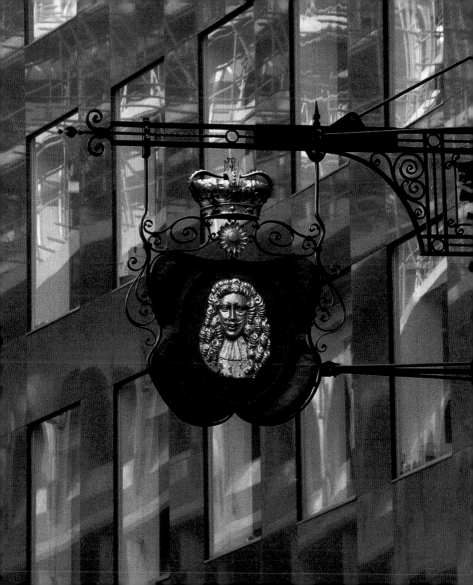

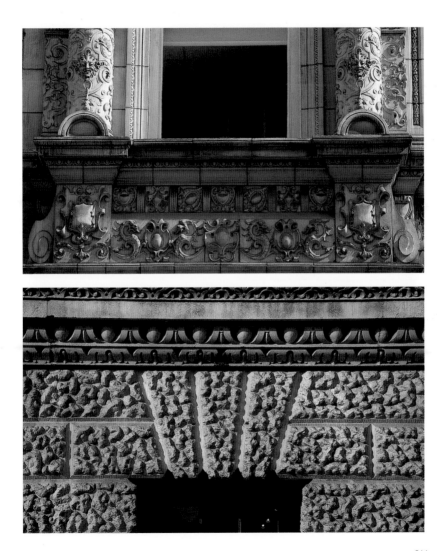

A barbershop in
Whitcomb Street near
Leicester Square.

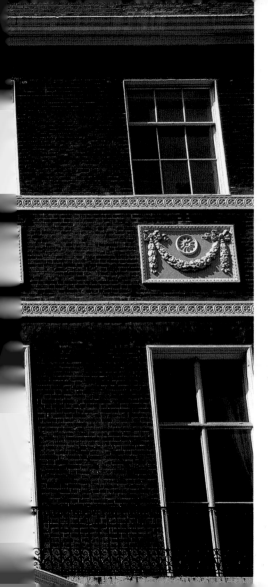

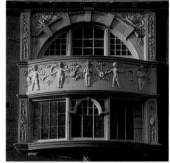

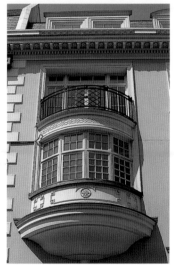

Left One of a pair of 1777 Robert Adam town houses in Portman Square, with distinctive decorative swagged plaques in Coade stone.
Top The BBC Television Theatre in Shepherd's Bush, formerly the Shepherd's Bush Empire, a music hall designed by Frank Matcham and opened in 1903.
Above A magnificent bow window in Mayfair.

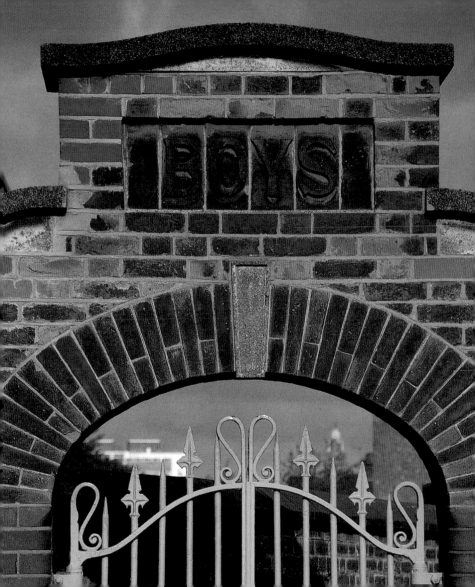

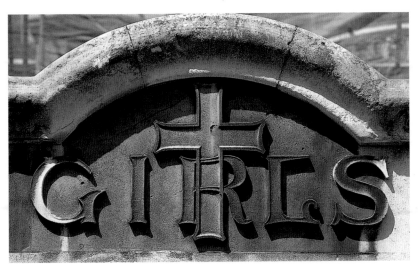

Girls' entrance to
a church school in
Mayfair **(above)** and
boys' entrance to
a school in Beckton,
East London
(opposite).

Stucco

To 'stucco' in English usage is to plaster a wall in imitation of stone. Plaster, which is made by burning gypsum, has been used in England since 1254. Over the centuries the addition of different ingredients, from cow-dung and straw to fine lime, horse hair and cement, has made it adaptable to many uses.

In England, and particularly in London, there was a convention that top people should live in houses of stone; brick was for the solid middle classes. Stone, however, was not always available and was costly, but if an ambitious man with insufficient wealth wished to rise in the world, he could at least have a house which looked like stone; a house built of brick, but covered in plaster and marked-out in ashlar as though it were built of square blocks with fine joints. It was a deception which quickly became a convention, and moreover it rested upon accepted precedents. Palladio had used it, and so had Lord Burlington on his Palladian villa in Chiswick.

Many such stuccoed villas dating from about 1750 to 1850 survive, particularly in Putney, Richmond and Hampstead, but it is with John Nash in Regent's Park that stucco reached its apotheosis. Nash was not only the architect, but was financially involved and needed to watch his costings; cheap buildings masked by plaster well suited his needs.

Cubitt followed in Belgravia with many streets and squares of grand houses. Although they were much better built than those of Nash, he conformed to the prevailing fashion of stucco fronts and brick backs. It was not until the end of the century that this class of house began to present an honest face to the world, and by that time their owners were cultivating different pretensions. Stucco is like pinchbeck gold and has only the appearance of reality. With Nash's buildings, the interiors have been replaced and only the stucco remains. Perhaps this says more about reality than it does about stucco.

A stuccoed façade of John Nash's Cumberland Terrace completed in 1828.

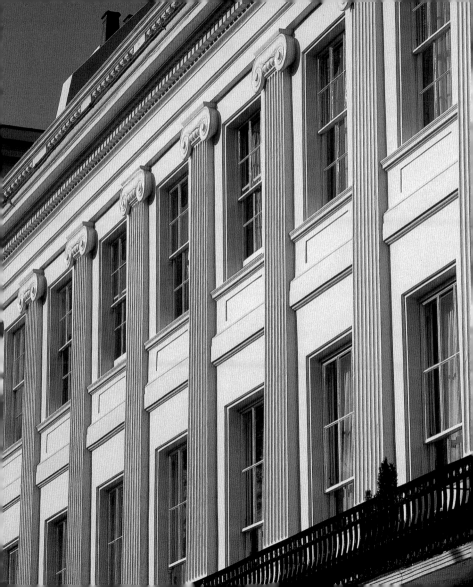

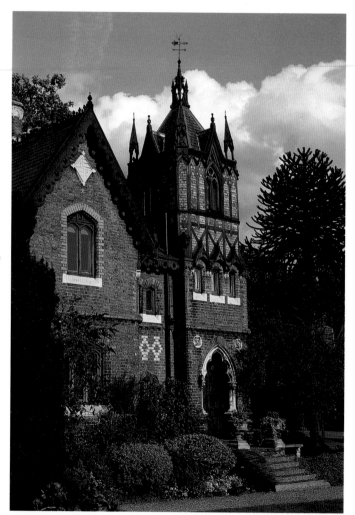

Holly Village,
Highgate. One of
a group of cottages
built by HA Darbishire
for Baroness Burdett
Coutts' servants.

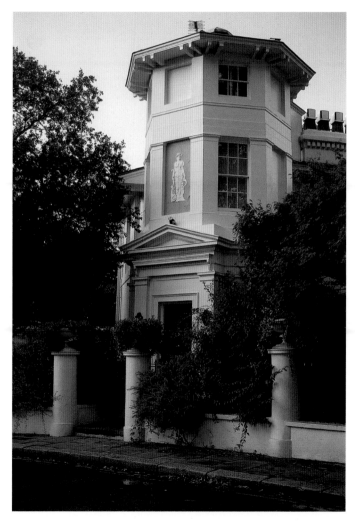

A stuccoed suburban villa in Park Village West, Regent's Park, designed in 1829 by John Nash with James Pennethorne in the classical style and inspired by the Tower of the Winds in Athens.

Following pages
222 The spire of Grosvenor Chapel, Mayfair, built by Benjamin Timbrell in 1739.
223 The extraordinary steeple of St George's, Bloomsbury, built by Nicholas Hawksmoor in 1731. Inspired by the Mausoleum of Halicarnassus, the steeple is surmounted by a statue of George I.
224/225 Carved brick masks in Mayfair.

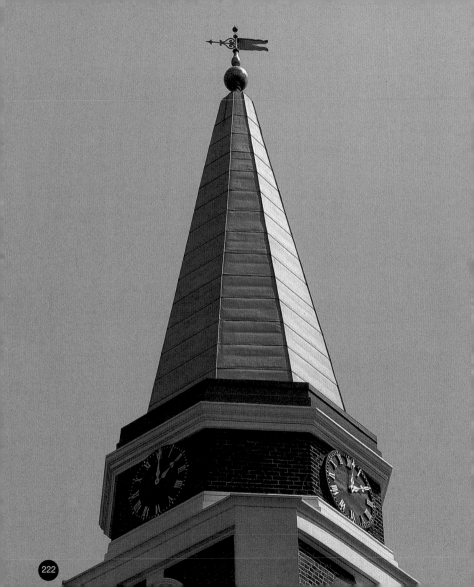

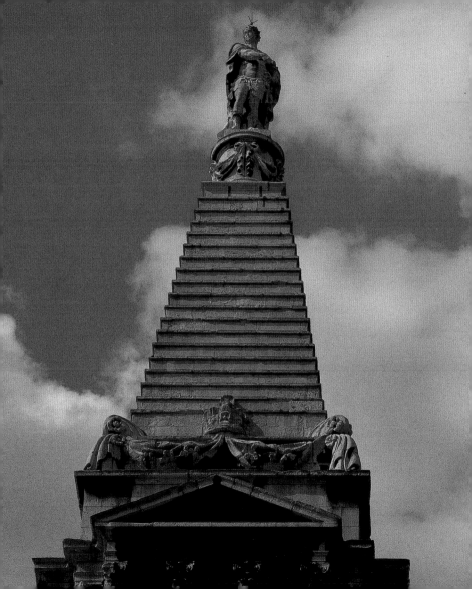

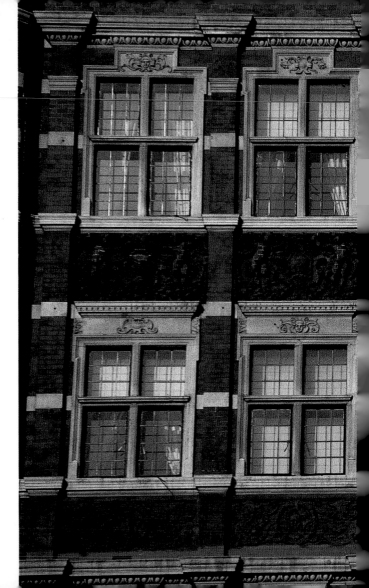

A carved brick and terracotta facade in Pall Mall.

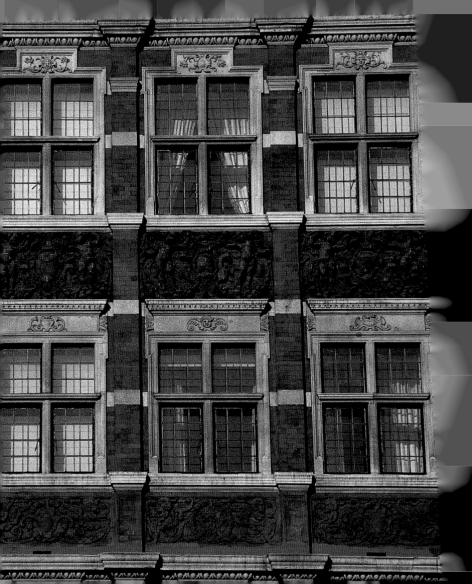

Columns and capitals

Medieval architects tended to use columns for interiors rather than exteriors, as in the tremendous Purbeck marble flanking the nave of Westminster Abbey. Columns are a more conspicuous part of classical architecture; this architectural language has proved enduringly powerful, and all over London Doric, Ionic and Corinthian columns serve as distant echoes of ancient pagan culture. The earliest surviving examples are in the Ionic loggia of Inigo Jones's Queen's House at Greenwich of 1616-40, and the attached columns on his magnificent Banqueting House of 1619-22. To commemorate the Great Fire, Sir Christopher Wren designed the Monument which stands at 202 feet and is the tallest isolated stone column in the world.

The column has proved powerful in this kind of commemorative role: the Duke of York's Column of 1830-34, between Carlton House Terraces, is a severe military-looking affair (it was paid for by taking a day's pay from every soldier in the army). Nelson's Column, designed by William Railton and built between 1839 and 1842, is Corinthian and more festive. Two good examples of the way in which columns serve to lend a public presence to a building are James Gibbs's perfect Corinthian portico at St Martin's-in-the-Fields which echoes Wilkins's portico of the National Gallery. Wilkins was bound by the requirement that he reuse the columns from Henry Holland's portico at Carlton House, demolished in c.1827. Throughout the 19th century, all manner of institutions from churches to livery halls, banks and the Bank of England itself, used columns to endow themselves with an air of age, permanence and authority; the classical portico remains a potent symbol of civic virtue.

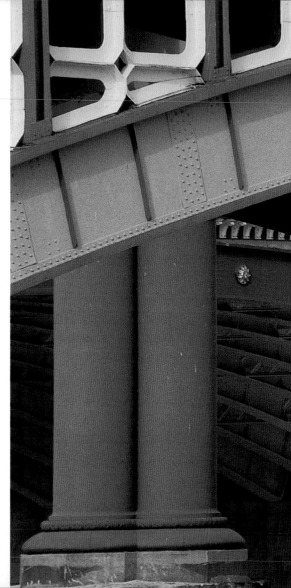

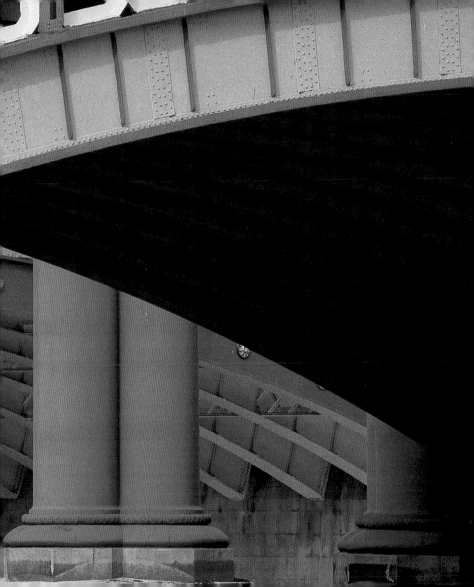

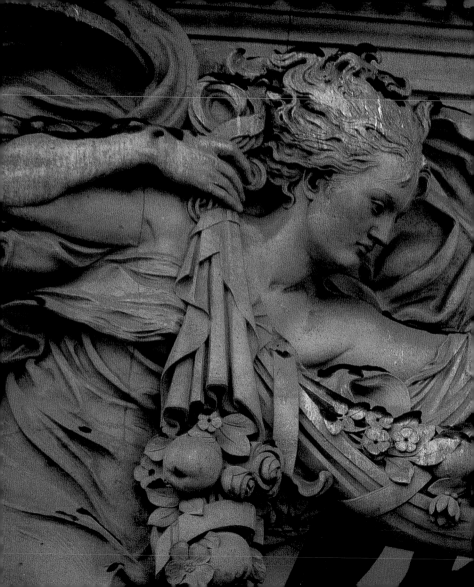

228/229 A stuccoed
profusion of
acanthus-decorated
corbels over a
Composite capital
on John Nash's
Cumberland Terrace
in Regent's Park
(top).
Bridges at
Blackfriars. The
massive cast-iron
Romanesque piers
of the old London,
Chatham & Dover
railway bridge
(now without its
superstructure),
flanked by
Blackfriars road
bridge and Canon
Street railway bridge
(right).

A detail of a soberly
clad maenad
together with fruit-
encumbered swags
sculpted by Henry
Poole from
Methodist Central
Hall in Westminster,
designed by
Lanchester and
Rickards and
completed 1911.

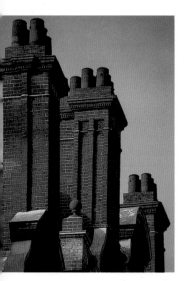

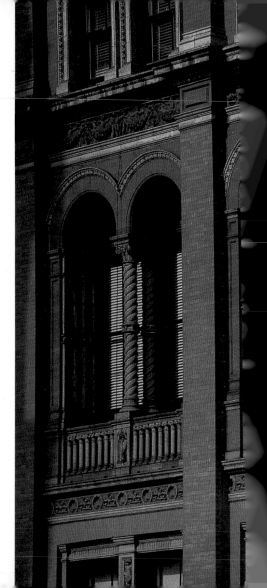

Above A row of 19th-century brick chimneys in Kensington in the so-called style of Queen Anne, prevalent throughout British architecture at the turn of the century.

Right The facade of the internal courtyard of the Victoria & Albert Museum, South Kensington.

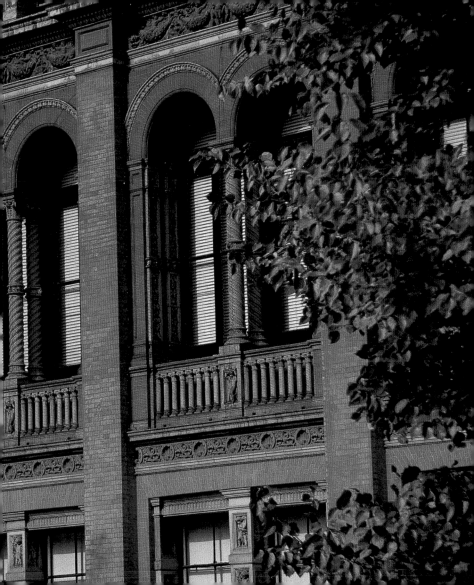

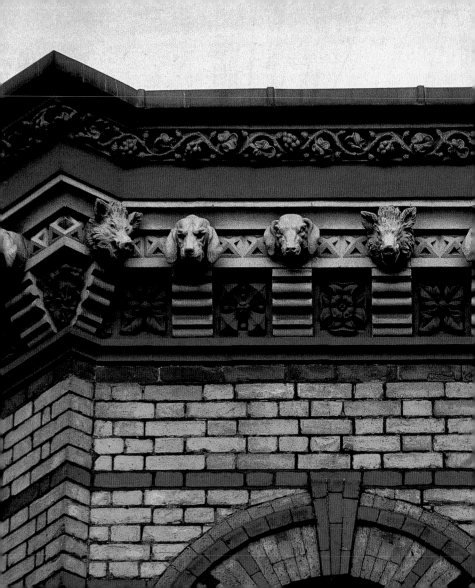

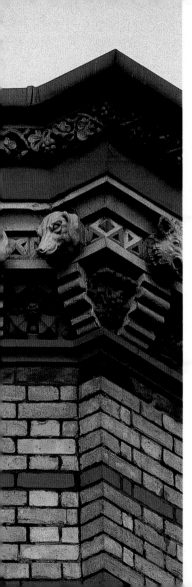

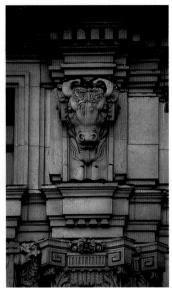

Above A detail from Methodist Central Hall, Westminster.

Left Eastcheap, the City. A corner face of this ornate building with its striking use of coloured brickwork, particularly in the decorative cornice high above the street. The dogs' and boars' heads may reflect the fact that the building was once occupied by 'Hunt' and Crombie, wholesale spice merchants.

Following pages
236 Part of a neo-classical door surround on the Inwood Brothers' St Pancras Church on Euston Road, Marylebone.
237 Decorative terracotta details with a repeating thistle motif, from Cardinal Vaughn School, Holland Park.

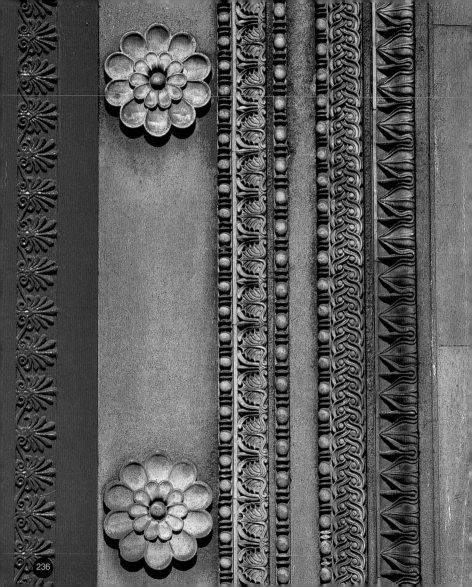

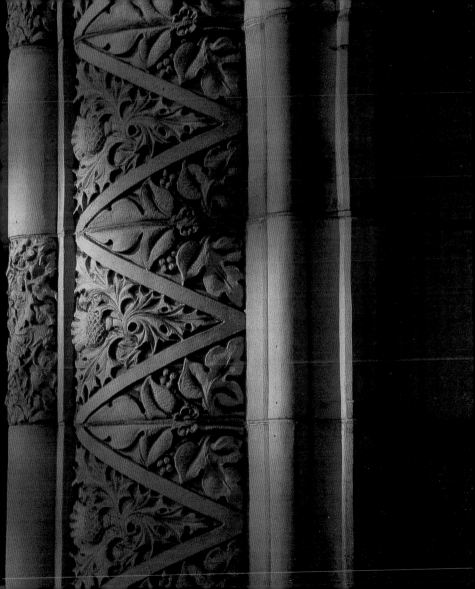

Further reading

Adams, Bernard London illustrated 1604-1851. A survey and index of topographical books & their plates, London, The Library Association, 1983

Barker, Felix and Peter Jackson The history of London in maps, London, Barrie & Jenkins, 1990

Betjeman, John Victorian and Edwardian London from old photographs, introduction and commentaries by John Betjeman, London, Batsford, 1970

Briggs, Martin S A short history of the building crafts, Oxford, Oxford University Press, 1925

Clifton-Taylor, Alec The pattern of English building, London, Faber, 1972

Clifton-Taylor, Alec and A S M Ireson English stone building, London, Gollancz, 1983

Collins, Peter Concrete. The vision of a new architecture. A study of Auguste Perret and his precursors, London, Faber, 1959

Colvin, Howard A biographical dictionary of British architects 1600-1840, London, John Murray, 1978

Cowen, Painton A guide to stained glass in Great Britain, London, Michael Joseph, 1985

Cresy, Edward An encyclopaedia of civil engineering, historical, theoretical, and practical, London, Longman, Brown etc., 1847

Crossley, F H Timber building in England from early times to the end of the 17th century, London, Batsford, 1951

Downes, Kerry The architecture of Wren, London, Granada, 1982

Friedman, Terry et al The alliance of sculpture and architecture. Hamo Thorneycroft, John Belcher and the Institute of Chartered Accountants Building, Leeds, Henry Moore Centre for the Study of Sculpture/Leeds City Art Galleries, 1993

Gernsheim, Helmut and Alison The history of photograpy, 2nd edition, London, Thames & Hudson, 1969

Getting London in perspective, exhibition catalogue, Barbican Art Gallery, preface by Ralph Hyde and John Hoole, London, 1984

Girouard, Mark Victorian pubs, London, Yale University Press, 1984

Girouard, Mark Sweetness and light. The Queen Anne movement 1860-1900, Oxford, Oxford University Press, 1977

Girouard, Mark Cities and people. A social and architectural history, London, Yale University Press, 1985

Glaister, G A Glaister's glossary of the book, 2nd edition, London, Allen & Unwin, 1979

Gloag, John and Derek Bridgwater A history of cast iron in architecture, London, Allen & Unwin, 1948

Goldschmidt, Lucien and Western J Naef The truthful lens. A survey of the photographically illustrated book 1844-1914, New York, The Grolier Club, 1980

Gray, A Stuart Edwardian architecture. A biographical dictionary, London, Duckworth, 1985

Harrison, Martin Victorian stained glass, London, Barrie & Jenkins, 1980

Hessenberg, Ian (ed.) London in detail, London, John Murray, 1986

Hitchcock, Henry-Russell Early Victorian architecture in Britain, 2 vols., London, Architectural Press, 1954

Hobhouse, Hermione Thomas Cubitt Master Builder, London, Macmillan, 1971

Hobhouse, Hermione Lost London: A century of demolition and decay, London, Macmillan, 1972

Hobhouse, Hermione and Ann Saunders (eds.) 'Good and proper materials. The fabric of London since the Great Fire.' Papers given at a conference organized by the Society of Antiquaries, 21 October 1988, London Topographical Society, 1989

Hoppé, E O The image of London. A hundred photographs, London, Chatto & Windus, c.1935

Hoppé, E O A camera on unknown London, London, Dent, 1937

Howgego, J L The city of London through artists' eyes, London, Collins, 1969

Innocent, C F The development of English building construction, Cambridge, Cambridge University Press, 1916

Jones, Edward and Christopher Woodward. A guide to the architecture of London, new edition, London, Weidenfeld, 1992

Kelly, Alison Coade's stone, Upton-upon-Severn, 1990

Lloyd, Nathanial A history of brickwork from Mediaeval times to the end of the Georgian period, London, Montgomery, 1925

Olsen, Donald The city as a work of art. London, Paris, Vienna, London, Yale University Press, 1986

Pevsner, Nikolaus *Studies in art, architecture & design*, 2 vols., London, Thames & Hudson, 1968

Pevsner, Nikolaus *The buildings of England. London Volume 1: The cities of London and Westminster*, 3rd edition, Harmondsworth, Penguin Books, 1973

Pevsner, Nikolaus and Bridget Cherry *The buildings of England. London Volume 2: South*, London, Penguin Books, 1983

Pevsner, Nikolaus and Bridget Cherry *The buildings of England. London Volume 3: North West*, London, Penguin Books, 1991

Piper, David *Artists' London*, London, Weidenfeld, 1982

Rasmussen, Steen Eiler *London the unique city*, London, Cape, 1937

Saint, Andrew *The image of the architect*, London, Yale University Press, 1983

Salzman, L F *Building down to 1540. A documentary history*, Oxford, Oxford University Press, 1969

Summerson, John *Architecture in Britain 1530 to 1830*, 4th edition, Harmondsworth, Penguin Books, 1963

Summerson, John *The life & work of John Nash architect*, London, Allen & Unwin, 1980

Thorne, Robert (ed.) *The iron revolution. Architects, engineers and structural innovation 1780-1880*, London, RIBA Heinz Gallery, 1990

Twyman, Michael *Lithography 1800-1850*, London, Oxford University Press, 1970

Weinreb, Ben and Christopher Hibbert *The London encyclopaedia*, London, Macmillan, 1983

West, T *The timber-framed house in England*, Taunton, David & Charles, 1971

Works referred to in the text

Ackermann, Rudolf *The microcosm of London*, London, Ackermann, 1808-10

Aubrey, John *Aubrey's Brief Lives*, edited from the original manuscripts and with an introduction by Oliver Lawson Dick, London, Secker & Warburg, 1968

Boys, Thomas Shotter *London as it is*, London, Thomas Boys, 1842

Cavaceppi, Bartol *Raccolta d'antiche statue, busti, bassirilievi ed altre sculture*, 3 vols., Rome, 1768-72

Caylus, An Cl Phil *Recueil d'antiquités égyptiennes, étrusques, grecques et romaines*, 7 vols., Paris 1752-67

Delamotte, Philip Henry *The progress of the Crystal Palace at Sydenham*, London, 1855

Dixon, Henry and the Society for Photography *Relics of Old London*, London, privately printed for the Society 1875-86

Doré, Gustave and Blanchard Jerrold *London a pilgrimage*, London, Grant, 1872

Elmes, James *Metropolitan improvements: or London in the nineteenth century displayed in a series of engravings of new buildings...from original drawings...by Mr Thos H Shepherd*, London, Jones, 1829-30

Exhibitions of the works of industry of all nations: Reports of the Juries, 3 vols., London, Spicer Brothers, 1852

Gernsheim, Helmut *Beautiful London. 103 photographs*, London, Phaidon, 1950

Stow, John *A survey of the cities of London and Westminster and the Borough of Southwark containing the original, antiquity, increase, present state and government of those cities written at first in the year...1598 by John Stow citizen and native of London. Corrected, improved and very much enlarged...by John Strype M A, a native also of the said city...*, London, Innys & Richardson, Knapton et al, 1754

Stuart, James and Nicholas Revett *The antiquities of Athens measured and delineated by James Stuart FRS & FSA and Nicholas Revett painters and architects*, 4 vols. folio, London, John Haberkorn, 1762, John Nichols, 1787, 1794, J Taylor, 1816

Talbot, William Henry Fox *The pencil of nature*, London, Longman, 1844

Index

Page numbers in **bold** refer to the illustrations